IMAGES
of America

AROUND MT. HELIX

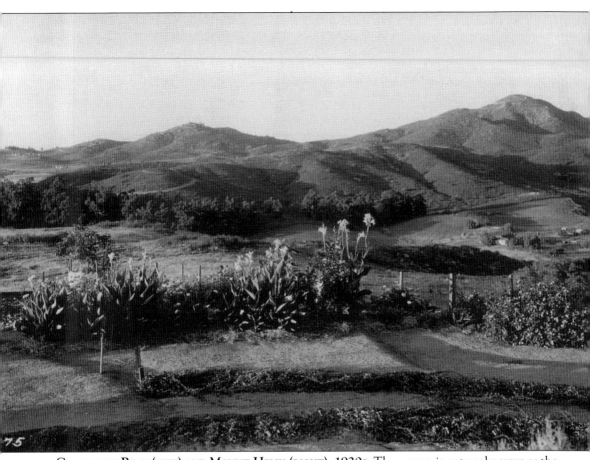

GROSSMONT PEAK (LEFT) AND MOUNT HELIX (RIGHT), 1920s. These prominent peaks serve as the geographic hubs of the Mount Helix area. Businessman Ed Fletcher purchased the old Alta Ranch in 1902, naming the northern peak and its residential development for his partner and noted entertainer William Gross. Spring Valley pioneer Rufus Porter named Mount Helix after scientist Louis Agassiz discovered *Helix aspersa* snails there in 1872. (La Mesa Historical Society.)

ON THE COVER: MT. HELIX NATURE THEATER, APRIL 12, 1925. Thousands fill the new outdoor amphitheater for the facility's initial mountaintop Easter sunrise service that inspired Cyrus Carpenter Yawkey and Mary Yawkey White to fund its construction on the prominent hilltop. This annual community tradition continues some 90 years later. (La Mesa Historical Society.)

IMAGES
of America

AROUND MT. HELIX

James D. Newland

ARCADIA
PUBLISHING

Published by Arcadia Publishing
Charleston, South Carolina

Printed in the United States of America

Library of Congress Control Number: 2015933931

For all general information, please contact Arcadia Publishing:
Telephone 843-853-2070
Fax 843-853-0044
E-mail sales@arcadiapublishing.com
For customer service and orders:
Toll-Free 1-888-313-2665

Visit us on the Internet at www.arcadiapublishing.com

The book is dedicated to all who have, past and present, endeavored to develop, preserve, and enhance these communities while being inspired by the cultural vantages revealed from this extraordinary pinnacle.

CONTENTS

ACKNOWLEDGMENTS

This book is the result of the dedication and persistence of Tracey Stotz, former Mt. Helix Park Foundation executive director, and John Mead, past president of the Grossmont-Mt. Helix Improvement Association. Also significantly notable is James Guy's generosity in opening his father, Hubert's, Grossmont collections—without Jim's participation, this project would not have been feasible. The La Mesa Historical Society Board of Directors deserves credit for their support in extending the society's interests for local history and cultural heritage eastward. Many other institutions, historians, archivists, and friends have provided assistance, inspiration, and photographs, including the dedicated photograph archivists of the San Diego History Center, Chris Travers and Carol Myers; historians Tom Adema, Steve Van Wormer, and Hubert Guy; San Diego Modernism expert and Lloyd Ruocco historian Todd Pitman; architect John Adams; designer Mic Mead; Budd and Vicki Willis; Alice Smith; Helen O'Field of the Lemon Grove Historical Society; Carol Surr of the Spring Valley Historical Society; Eldonna Lay and Mike Kaszuba of the El Cajon Historical Society; the Helix Water District's Kate Breece; Armando Buelna and Mark Robak of Otay Water District; Connie and Lynn Baer of the Grossmont High School Museum; Trinity Presbyterian Church; Santa Sophia Catholic Church, world champion Little Leaguer Chico Leonard; Herb Dallas of CalFire; Anne Krueger of Grossmont Community College District; and the principals and staff of Grossmont, Helix, Mount Miguel, Monte Vista, and Valhalla High Schools, as well as those of the Cajon Valley School District Office, Fuerte Elementary, and Hillsdale Middle School. Additional thanks go to editor Lily Watkins's tried but accommodating patience. If I ever get to the Palmetto State or you visit SoCal, I owe you a pint or two of your choice. Once again, no greater thanks and profession of love can go to my wife, Jennifer, and daughter, Lindsay, for their sacrifices in living with me through yet another book.

INTRODUCTION

In 1872, world-renowned pioneering natural scientist Louis Agassiz clambered across the rocky cylindrical peaked mountain bounding the northern slope of San Diego County's San Jorge Valley (today's Spring Valley). On what would turn out to be the final scientific expedition on the Swiss-born naturalist's lifelong professional quest to identify the planet's unique flora and fauna, he had a surprising discovery. Agassiz found *Helix aspersa* snails. In this place, then considered a remote and exotic landscape (especially to northern Europeans and Easterners), Agassiz's discovery of this native European gastropod apparently perplexed him. Such was his supposed amazement that his host, local rancher Rufus Porter, felt compelled to honor the noted scientist's visit and unique discovery by naming the sighting's location Mount Helix.

It is uncertain that the 1,375-foot-high pinnacle had a previous name. Its steep, rocky slopes were not conducive for permanent settlement or significant resource procurement, but it certainly had been an icon for the native Kumeyaay people, who for centuries inhabited and prospered in the surrounding spring-fed fertile valleys. For the pioneering Euro-Americans of the area, it also served as a geographic landmark. Travelers to San Diego, both to and from the east, would encounter and identify this landmark pinnacle on their journeys. They would do so if they traveled the Chollas and Cajon Roads that passed over the mesa that stretched east from the frontier city and ended at the Alta Pass (now Grossmont Pass), which led into the El Cajon Valley, or if traversing along the more southerly federal route that roughly follows State Highway 94 today. Either way, Mount Helix provided, as it still does, a familiar and distinctive geological signpost and natural milestone.

Additionally, Mount Helix serves, even more concretely, and not just due to its historic nature theater and park, as a cultural beacon and focal point for today's mostly unincorporated surrounding communities of Mount Helix, Grossmont, Calavo Gardens, Casa de Oro, Rancho San Diego, and Spring Valley. Its iconic influence is also apparent to the adjacent historically related municipalities of El Cajon, Lemon Grove, and La Mesa. Especially for the current 20,000 residents of the surrounding semirural suburban neighborhoods, these areas within Mount Helix's shadow are now renowned for their idyllic family-friendly rural suburban landscapes, classic early-20th century Revival-style and custom Mid-Century Modern homes and buildings, and long-standing community institutions.

The story of how these lands around Mount Helix developed into well-known and iconic semirural suburban communities is both consistent with—and yet in many ways, contradictory—to San Diego County's typical land-use development narrative. Originally, 19th-century American settlers and speculators had identified these lands as promising hinterlands for traditional agriculture-based rural farming communities similar to their previous homes in the Midwest and East. In the early-20th century, others saw these still mostly undeveloped and unfettered lands as having a potential for more progressive utopian settlements that embraced new ideas, innovation, and cutting-edge melding of the best of rural and suburban amenities and values. Likely inspired by

the vistas encountered from atop Mount Helix or other local inspirational promontories such as Grossmont Peak, Spring Valley's Dictionary Hill, or the even higher and more prominent San Miguel Mountain to the south, early local 20th-century developers, promoters, and civic leaders planned and set into motion cutting-edge semirural tracts with suburban amenities and subsequent community institutions.

Although the area would have visionary utopian colonies (Grossmont) and "gentlemen's avocado ranchette" developments (Calavo Gardens and Casa de Oro) slowed and stymied by the Great Depression and World War II, the foundations for creating unique rural suburbia in the Mount Helix area were formed. Therefore, when the massive suburban Sun Belt sprawl fed post–World War II San Diego County's exponential growth into the millions of residents, the Mount Helix region was primed for following its own unique suburban destiny. The area served as a welcoming landscape for the new generation of postwar nuclear-family suburbanites and their innovative architects who embraced the ideals of contemporary living reflected in Mid-Century Modern design. This was all conceived within the context of the popular indoor-outdoor Sunset magazine–promoted California rural/suburban lifestyle that quickly became iconic of the postwar American Dream. Consequently, the area's development included the breadth of higher-end custom architecture and landscape along with entry-level postwar tracts (Brookside or Spring Valley Estates), as well as early preplanned community-scale developments such as Rancho San Diego. Subsequently, the vast majority of the Mount Helix area's development and population growth dates to the post–World War II era.

Yet the region's cultural history extends back many centuries. The Kumeyaay had lived, as they continue to do, in the region of today's southern San Diego County and upper Baja California. Although contact with Euro-Americans had occurred with Spanish explorers starting in the mid-16th century, it was not until the Spanish colonials occupied Alta California in the late-18th century that the documented history of the Mount Helix area begins.

The Spanish established the original Mission San Diego de Alcala in 1769 at Presidio Hill near today's Old Town San Diego. They relocated the mission upriver to its current location in 1774 to be closer to a consistent water source and the Kumeyaay village of Nipaguay. The missionaries' conversion of the native population was a key element in the Spanish plans for bringing remote Alta California into their colonial empire. The missionaries not only identified areas to plant crops and graze livestock but also recruited converts. It is from the mission records that we first learn of the Kumeyaay of the Mount Helix area. From the Spanish, we get the first documentation of the local Kumeyaay villages identified as Meti, Matamo, Jamocha, and Secua. Over time, the Spanish would translate and rename these places. Meti, with its numerous natural springs, would be renamed El Aguaje de San Jorge (the springs of St. George), today's Spring Valley. The apparent village east of Helix was renamed Rancheria de San Juan Capistrano, more commonly called Matamo. Below that area, the village of Jamocha would become known as the Rancheria San Jacome de la Marca or Jamacha. Farther east along the Sweetwater River Valley was Secua—Hispanicized into today's Secuan.

The Spanish established their colonial system in order to institutionalize their claims to territories such as Alta California through introduction of new land uses such as intensive agriculture and stock grazing. They also instituted new social and political systems that rapidly altered the centuries-old cultural landscape of the Kumeyaay and disrupted their traditional way of life. Subsequently, the lands surrounding Mount Helix were encompassed within the newly established jurisdiction of the Mission San Diego de Alcala. The Kumeyaay's resolute and independent nature and the struggles in establishing agriculture into the arid landscape challenged the aspirations of the Spanish. In spite of these challenges, the Mission established San Jorge, San Juan Capistrano de Matamo, and Jamacha as grazing lands for sheep, horses, and cattle. In the nearby valley of Santa Monica—or El Cajon (the box), as it was commonly known—the missionaries planted vineyards and fields along the banks of the San Diego River located at the valley's northern boundary.

When Mexico received its independence from Spain in 1821, the power and authority of the missions declined. In Alta California, the Mexican government secularized the missions and

distributed their former lands and property to private citizens. During the Mexican Republic Period (1821–1846), near 30 private ranchos were claimed in today's San Diego County alone. Those grants directly related to the land around Mount Helix included Rancho Jamacha, Rancho Santa Monica (El Cajon), and the Rancho Ex-Mission San Diego. The first two grants were somewhat unique. Although most California ranchos had been granted to the wealthy upper-class gentlemen (*gente de razon*) of the territory, Rancho Jamacha was given to Doña Apolinaria Lorenzana, an unmarried pious woman who had dedicated her life to the Mission San Diego and the church. In 1840, Governor Alvarado confirmed Rancho Jamacha's 8,881 acres, encompassing the lands of Jamacha and Secuan, to Lorenzana. In 1845, Gov. Pio Pico (also owner of nearby Rancho Jamul) granted the 48,800-acre Rancho El Cajon, which includes most of today's cities of El Cajon, Santee, and Lakeside, to Doña Maria Antonia Estudillo de Pedrorena, daughter of San Diego's former alcalde (de facto mayor) and wife of prominent Spanish-born merchant Miguel Pedrorena. In 1846, as the United States prepared to occupy the territory at the beginning of the war with Mexico, Governor Pico hastily granted the remaining Rancho Ex-Mission San Diego lands to former San Diego Presidio commandant Santiago Arguello. Arguello's grant would later be confirmed at 58,875 acres and include much of San Diego east of Interstate 805 and most of today's cities of Lemon Grove and La Mesa.

After the United States acquired Alta California in 1848, the owners of Mexican land grants would be required to confirm their titles. These land claims would therefore be caught in decades of lengthy and costly litigation that would not be cleared until the mid-1880s. When the final surveys and court settlements were complete, interestingly, most of the San Jorge Valley (Spring Valley) and the lands directly surrounding Mount Helix, Grossmont, and Calavo Gardens/Casa de Oro would be excluded. As such, much of Mount Helix and Spring Valley fell in-between the final rancho boundaries. This determination that these lands were still part of the public domain and open to settlement allowed earlier community development of Spring Valley than its western neighbors La Mesa and Lemon Grove, whose lands were caught up in the unsure title of the Ex-Mission grant.

It is therefore a focus of this historical narrative to trace the story of these distinctive and unique lands in-between, as they have intertwined with the collective histories of their neighboring communities, key individuals, and shared institutions. As noted previously, the heart of this story centers on the influence of Mount Helix with its unprecedented private "public" park and community-based outdoor nature theater as a regionally significant natural and cultural landmark. Covering such a diverse narrative and geographic scope is the challenge that I, as author, have endeavored to undertake. The breadth of this region's story provides far more interesting stories and historical images than can be accommodated in this particular book. Any specific omissions are my responsibility, and no slight should be inferred by the absence of key landmarks, institutions, or individuals.

It is hoped that this book's brief introduction to the rich heritage around Mount Helix will provide residents, neighbors, visitors, and interested parties some insight into the collective and relatable experiences these unique communities and their universal stories reveal. Thanks again to all the individuals, institutions, and archives who contributed images, input, and support.

Images are courtesy of the La Mesa Historical Society or Mt. Helix Park Foundation unless otherwise noted.

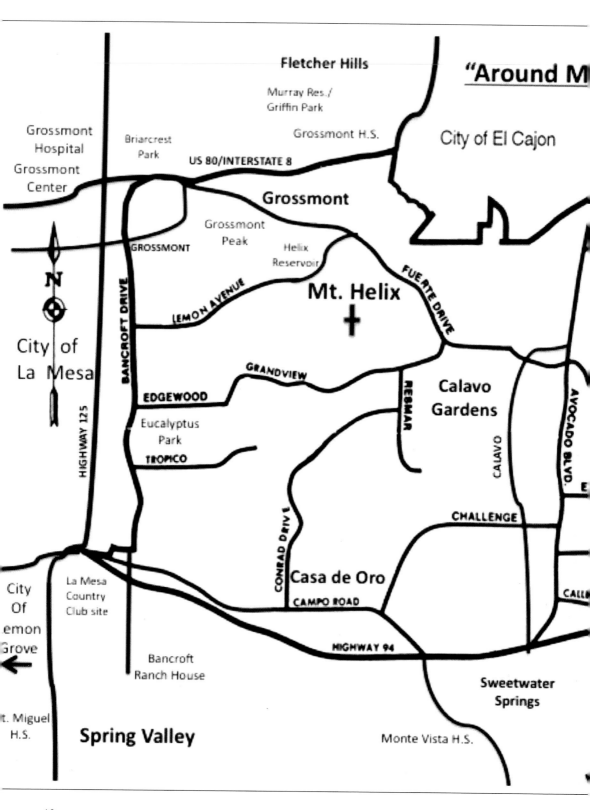

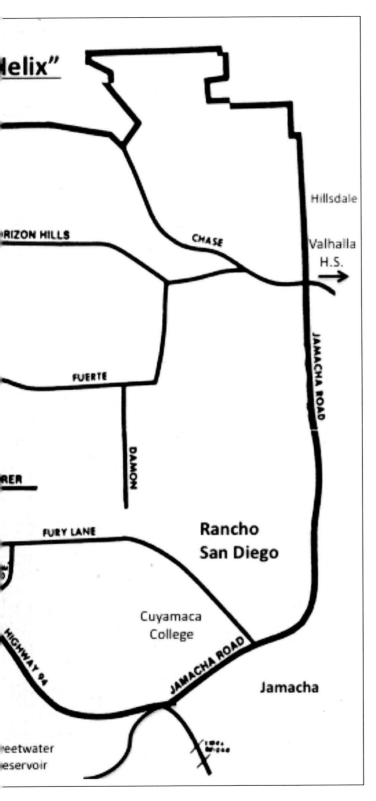

MOUNT HELIX AND VICINITY MAP. The prominent cylindrical peak of Mount Helix serves as the geographic hub of these historically related rural suburban neighborhoods and communities. These mostly unincorporated communities, including Grossmont, Mount Helix, Calavo Gardens, Rancho San Diego, Casa de Oro, and Spring Valley, have a shared heritage with their incorporated neighbors of El Cajon, La Mesa, and Lemon Grove. Today, the Grossmont-Mt. Helix Improvement Association's (GMIA) boundaries (Bancroft Drive, State Route 94, Jamacha Road, Interstate 8, and the city of El Cajon) represent the core areas around Mount Helix that all look toward its unique privately owned public park and historic nature theater for their civic and social inspiration (based on the GMIA boundary map).

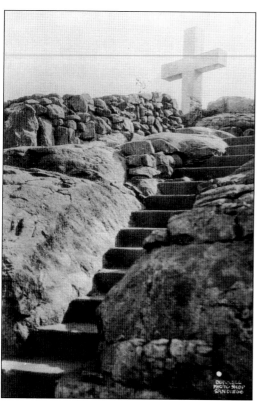

OLD RUGGED CROSS AT MOUNT HELIX, c. 1925. Although relatively new, the cross atop Mount Helix immediately became a regional symbol, as illustrated by this mid-1920s postcard print. Architect Richard Requa's rustic Arts and Crafts–style Mt. Helix Nature Theater reflects on the natural and cultural significance of this local landmark.

EL CAJON MERCHANTS' OUTING AT GROSSMONT PEAK, 1915. Nearby Grossmont Peak held a similar affiliation for local civic and business leaders. Developer Ed Fletcher's 1913 opening of the peak's narrow, precipitous dirt road provided access to this inspirational view. These El Cajon merchants took advantage to envision the region's future potential. (El Cajon Historical Society.)

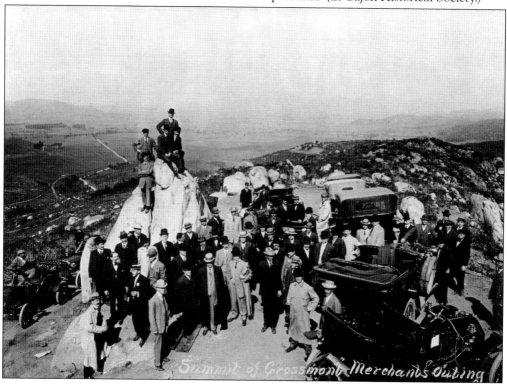

One

THE LAND IN-BETWEEN
PREHISTORY TO 1902

Mount Helix's cultural history spans centuries. The native Kumeyaay utilized the abundant natural resources found locally to support a long-standing regionally stable society. Their world was forever altered with the arrival of the Spanish missionaries who established Mission San Diego nearby. The Spanish introduction of stock grazing and intensive agriculture, as well as new social structures and epidemic-inducing diseases, forever disrupted and rapidly weakened the Kumeyaay's centuries-old cultural landscape. Mexican independence from Spain in 1821 resulted in the eventual dismantling of the mission system. During the Mexican Republic period, the former mission lands in the El Cajon and Jamacha Valleys and those west of Mount Helix were distributed to individual Mexican Californios. After the United States acquired California in 1848, another set of social, political, and legal requirements—including onerous procedures for establishing title to these preceding Mexican land claims—ensued. Clearing title for these lands took several decades of long and expensive court cases and surveys, hampering sales, purchases and settlement. Interestingly, the results of these legal proceedings determined that much of the San Jorge Valley (Spring Valley) and those sections directly around Mount Helix were open for settlement. As such, pioneers of the Spring Valley area, including transplanted New Englanders Augustus Ensworth and Rufus Porter and purchasers of the Rancho Jamacha, such as English immigrant Robert Kelly, made early attempts at making a living from these semi-arid lands. Soon, these settlements grew enough to require public schools at El Cajon (1870) and Jamacha/ Spring Valley (1877). Therefore, when the great 1880s Southern California land boom ensued, the "land in-between" was enjoined in the frenzy. Speculators soon arrived with plans for capturing and distributing San Diego and Sweetwater River waters to support the area's agricultural and community development. Their dreams also included building railroads to connect San Diego and these agricultural hinterlands with the markets locally and to the east. Although many of these dreams would be sidetracked by the boom's bust in 1889 and a long-term drought at the turn of the 20th century, much of the underlying infrastructure for future development was established.

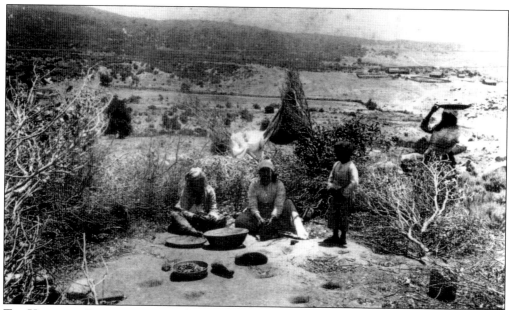

THE KUMEYAAY PEOPLE, C. 1900. The Kumeyaay's territory extended from the coast of San Diego County east across the mountains to the Colorado Desert and south into Baja California. They sustained themselves through hunting, gathering, and fishing and practiced brush burning, seed broadcasting, and transplanting. Excellent potters and basket makers, they organized socially into autonomous villages, such as those within sight of Mount Helix, including Meti, Jamocha, and Secau.

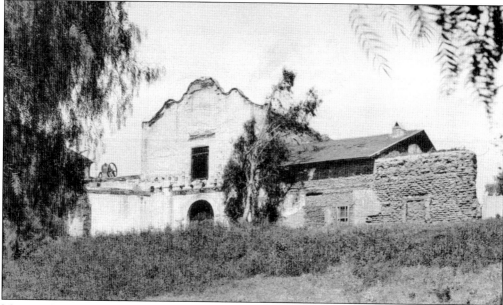

MISSION SAN DIEGO, 1890s. Mission San Diego de Alcala was moved to its current location to assist in conversion of local Kumeyaay. The Kumeyaay's resolute and independent nature was confirmed when a large group, including members from the aforementioned villages, attacked and burned the mission in November 1775. Fr. Luis Jayme was killed, but the mission would recover and continue its conversion efforts.

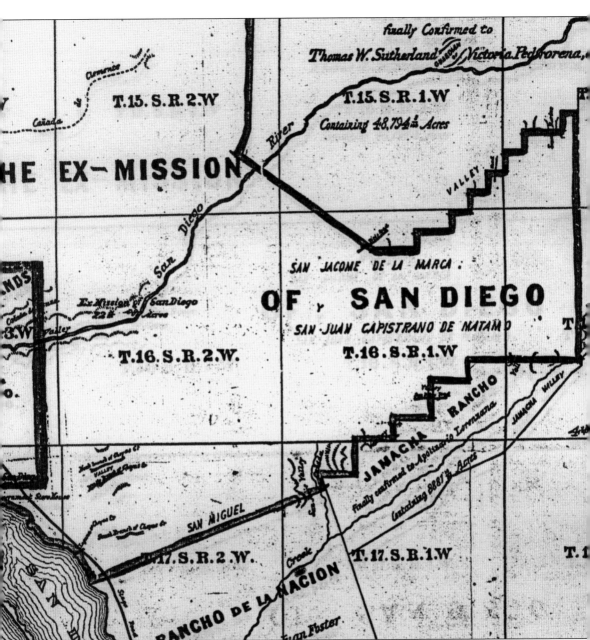

Ex-Mission Rancho Exception Case Map, 1869. This court case map is cropped with Mount Helix near its center. It documents place names adapted from the Kumeyaay. The missionaries and their neophyte workers accessed these mission lands by traveling across the mesa above the south rim of Mission Valley either through Alvarado Canyon or by trails following Indian routes that went up Fairmount Canyon across today's College Neighborhoods toward Lemon Grove and out to the Valle de San Jorge (Spring Valley). An 1827 mission report noted that the well-watered San Jorge housed mission sheep and was planted with cotton. San Jacome de la Marca (Jamacha) and San Juan Capistrano de Matamo (Calavo) and the mesas to the west served as grazing lands for mission horses, sheep, and mules. Jamacha and Santa Monica (El Cajon) supported fields along the Sweetwater and San Diego Rivers, as well as stock grazing.

PIONEERING THE LANDS IN-BETWEEN, EX-MISSION PLAT MAP, C. 1876. After the United States acquired California, new laws challenged the legitimacy of Mexican land grants. Rancho Jamacha went through, as historian Stephen Van Wormer wrote, some legal hocus-pocus before its title was settled in 1881. English immigrant Robert Kelly, one of several speculators that purchased the rancho in 1853, operated a stock ranch until 1858. In the 1870s, other settlers homesteaded in and around the Jamacha Ranch property. Yet, as surveyors defined the final boundaries of the former mission, it became apparent that the lands in between the three ranchos were available (labeled "Public Land"). In 1853, New England attorney Augustus Ensworth was the first to make a preemption claim on the open lands near one of San Jorge's flowing springs. Ensworth improved the property, but after what proved to be a fatal injury, he was forced to sell. Another New Englander, Rufus Porter, purchased Ensworth's Ranch in 1865. Porter would become the pioneering catalyst for settlement of the old San Jorge Valley.

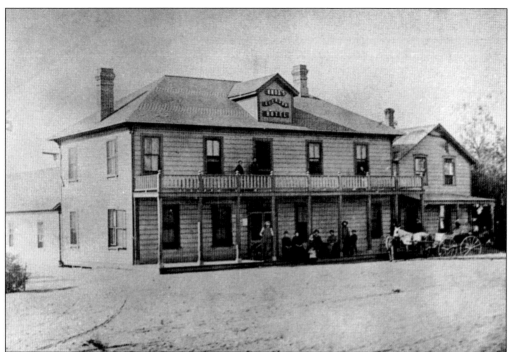

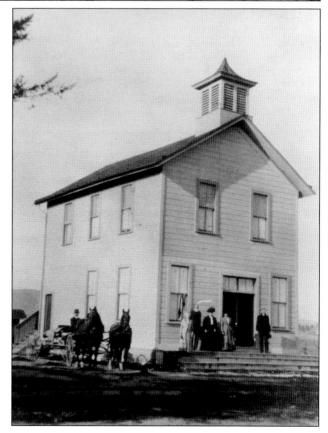

EL CAJON'S KNOX HOTEL, 1880S, AND EL CAJON'S FIRST SCHOOLHOUSE, 1885. In 1868, San Francisco land speculator Isaac Lankershim obtained the Rancho El Cajon. His attorney Levi Chase spent years clearing its title. Chase's reward would be over 7,000 acres in the property's southern end, where he settled. Another Lankershim employee, Amaziah Knox, obtained 10 acres for his services, choosing a prime location along the main road that traveled east from San Diego over the mesa, past Allison's Springs, and through the Alta Pass into El Cajon and beyond. In 1876, Knox and his wife, Illa Birdseye Knox, established a hotel and road station there. Knox's Corners became a commercial and community center. The valley farmers established their first institution, the El Cajon School District, in October 1870, constructing this first dedicated schoolhouse in 1880. (Both, El Cajon Historical Society.)

PORTER RANCH, SPRING VALLEY, C. 1880. Rufus Porter, a former schoolteacher, postmaster, and salt miner, and his family successfully improved their San Jorge Ranch. Porter renamed it Spring Valley at his daughter Rufina's request and promoted settlement there in *San Francisco Bulletin* newspaper columns. During the 1870s, additional pioneering ranchers settled onto the available and fertile spring-fed lands. (San Diego History Center).

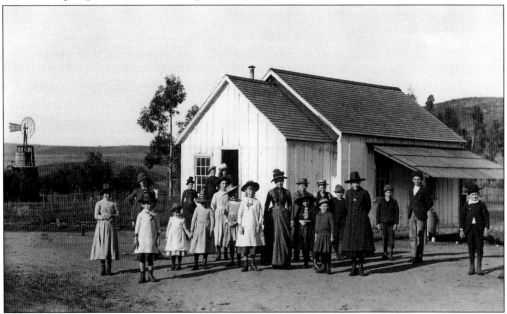

FIRST SPRING VALLEY SCHOOL, C. 1888. In 1877, Spring Valley pioneers Charles Crosby, Allen Burbeck, Rufus Porter, and others established the Jamacha School District. In 1881, they built their first schoolhouse just south of Porter's Ranch, later renamed Spring Valley School. This original building served as a center of civic and social activity for the small rural farming community. (San Diego History Center).

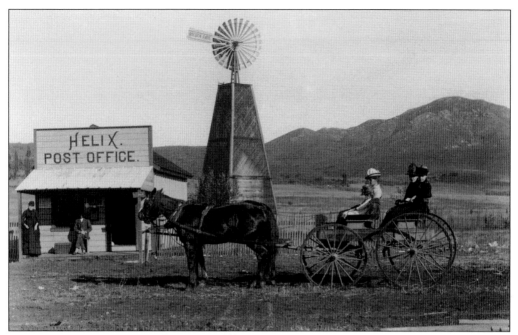

HELIX POST OFFICE, 1887. Rufus Porter sold his property to noted historian Hubert Howe Bancroft, who occupied and renamed it Helix Ranch in 1887. This sale coincided with the Southern California land boom of the 1880s. Soon, San Diego County was swarmed with land speculators hopeful to subdivide and profit. Spring Valley resident Hiram Stiles platted such a tract called Helix on his land, prompting construction of this new post office.

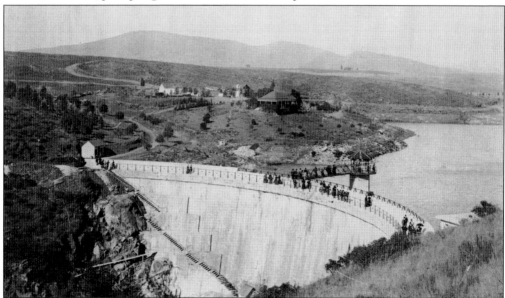

SWEETWATER DAM, 1892. As with many boom-era "paper" tracts, Helix saw little development. However, some boom-era improvements became permanent, such as James Schuyler's 1888 engineering landmark. The dam was meant to supply essential water downstream to National City as well as local speculative tracts, including La Presa (current south Spring Valley), San Miguel City (across the reservoir), and the aforementioned Helix. (El Cajon Historical Society.)

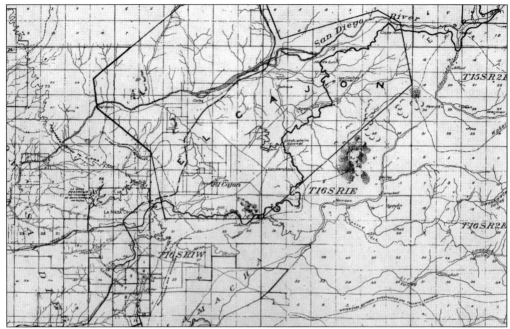

San Diego Flume System Map, 1885, and Eucalyptus Reservoir, c. 1900. Entrepreneur Theodore Van Dyke had an even more audacious plan to bring San Diego River water to the lands surrounding Mount Helix and beyond. Van Dyke worked with engineers, speculators, and key politicians to incorporate the San Diego Flume Company in 1885. The plan included capturing and diverting the river's water in the Cuyamaca Mountains and transporting it through 36 miles of wooden flumes and tunnels around the El Cajon Valley over the Alta Pass to the Eucalyptus Reservoir (today's Briercrest Park). Then the water would be transferred to a holding reservoir (today's Lake Murray) for use in their La Mesa Colony tract and south and west to investor Robert Allison's lands in La Mesa and Lemon Grove. The flume opened in 1889.

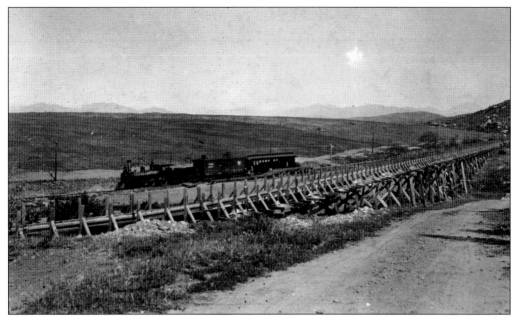

CAJON HEIGHTS/ALTA STATION, C. 1891. Another boom-era improvement was Gov. Robert Waterman's San Diego & Cuyamaca Eastern Railway (SDCE). Its Alta Pass Station, with the flume alongside, was near Enoch and Illa Birdseye's original 1875 El Cajon Heights Ranch, and Dan Manning's 1880s road station (near today's Interstate 8 and State Route 125 exchange). After Birdseye's death in 1876, the property sat idle until the SDCE railroad's 1889 arrival.

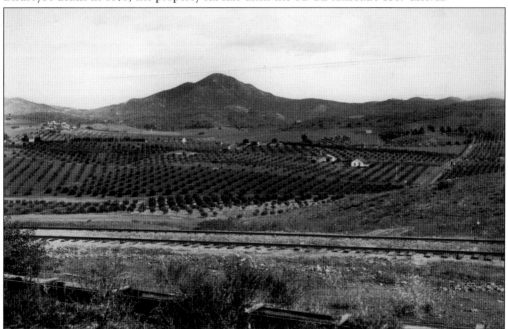

SPRING VALLEY, 1890S. The SDCE route connected San Diego with Robert Allison's Lemon Grove, Spring Valley, and Allison Springs (later La Mesa Springs) lands and over the Alta Pass to El Cajon. Pictured here are the citrus ranches of Spring Valley that received water from Allison's Lemon Grove flume in the foreground. Mount Helix is in the center.

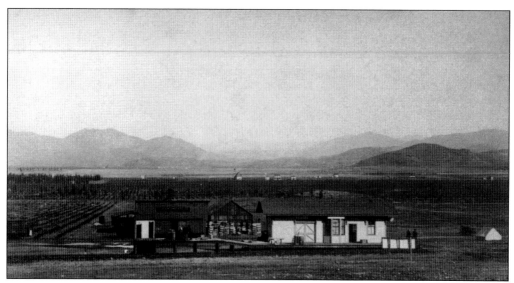

EL CAJON VINEYARD COMPANY AND SDCE STATION, 1890. The SDCE's El Cajon Station helped connect the fertile valley's produce with outside markets. Charles Johnson's El Cajon Vineyard Company represented the valley's oft-forgotten leadership in raisin production in the 1890s and early 1900s. Johnson eventually purchased the old El Cajon Heights ranch as part of the Vineyard Company's holdings.

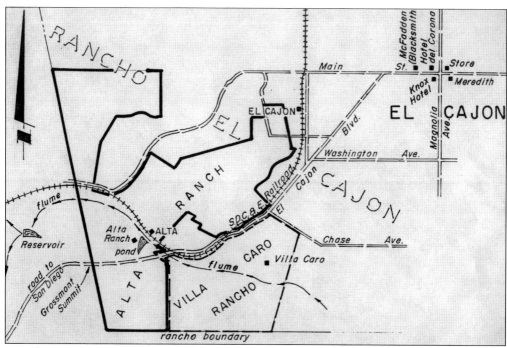

ALTA/VILLA CARO RANCHES MAP, C. 1895. Johnson's Vineyard Company sold off most his holdings on the Heights. This map from Hubert Guy's Grossmont book identifies the two ranches that were established in the Alta Pass area. Since the San Diego flume and railroad traveled through them, they were primed for agricultural development, thus attracting a prominent purchaser for each. (Guy collection.)

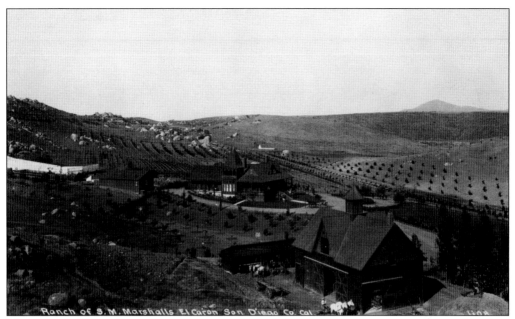

MARSHALL'S VILLA CARO RANCH, 1889. One of these properties was pioneer rancher Sam Marshall's Villa Caro Ranch on the north face of today's Grossmont. Marshall, who like Johnson has an El Cajon street named after him, built this Victorian ranch house and planted orchards. In 1895, as debts threatened foreclosure, Marshall sold the ranch to his neighbor Hervey Parke. (El Cajon Historical Society.)

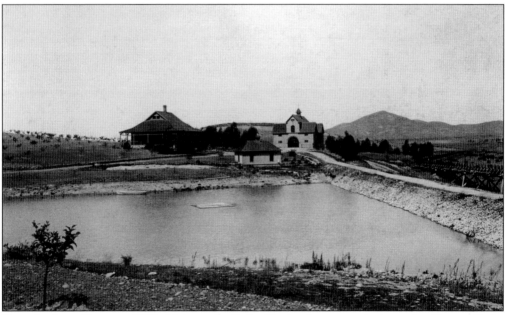

PARKE'S ALTA RANCH, 1895. Heir to the Parke-Davis pharmaceutical empire, Hervey Parke was visiting friend Col. James Randlett of Allison Springs in 1893 when he purchased El Cajon Heights, which he renamed the Alta Ranch. Parke built his large house and barn next to this spring-fed pond (now behind Anthony's Restaurant) and planted lemon orchards and crops. His unexpected death in 1899 made this valuable property available.

HILLSDALE SCHOOL, c. 1900. Most of the rocky, unwatered land east of Mount Helix was still undeveloped. However, enough settlers had moved into these lands along the road from Cajon to Jamacha, that they formed a small school district named Hillsdale in 1896. Typical of the small one-room rural schoolhouse, it became the community's civic center. (Cajon Valley School District.)

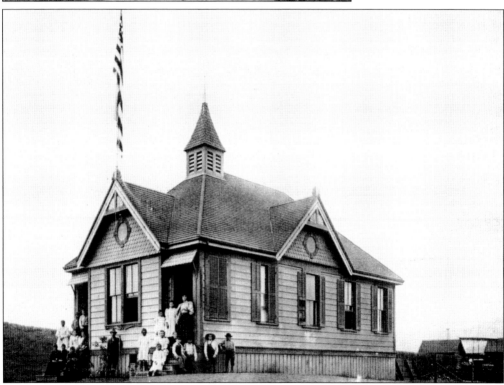

JAMUL SCHOOL, 1890s. In 1884, the farmers of Jamacha Valley established their own school near pioneer James Murphy's ranch. Just like the 1881 Spring Valley, 1891 La Mesa (College Area), 1895 Allison Springs (La Mesa), and 1896 Hillsdale Schools, and this one built in 1882 at Jamul, these rural one-room schoolhouses also provided community venues for meetings, social gatherings, and religious services. (Cajon Valley School District.)

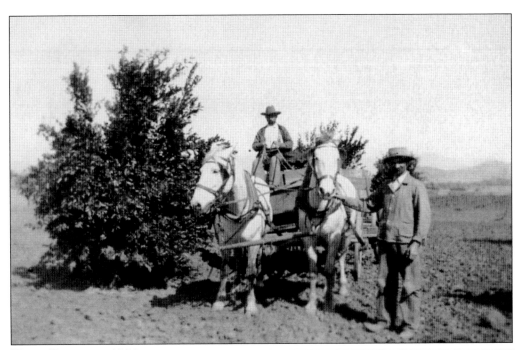

HINCK RANCH, C. 1900.
Many Spring Valley, El
Cajon, Jamacha, and La Mesa
ranchers arrived with capital
to establish themselves as
semiretired gentlemen ranchers.
Others had to make their
homesteads support them and
their families. Here, Claus
Hinck stands proudly with
his team and wagon at his
Mariposa Road citrus ranch
west of Eucalyptus Canyon.

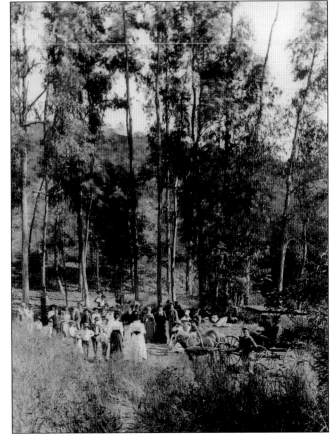

EUCALYPTUS CANYON, 1890.
Charles Crosby, Spring Valley
pioneer and Rufus Porter's
son-in-law, had joined in the
movement to plant eucalyptus
trees as a timber source for arid
California. In 1880, he planted
dozens in a small canyon on
the north end of his property.
Named Eucalyptus Canyon
by the locals, it became a
popular community gathering
spot for picnics and outings.

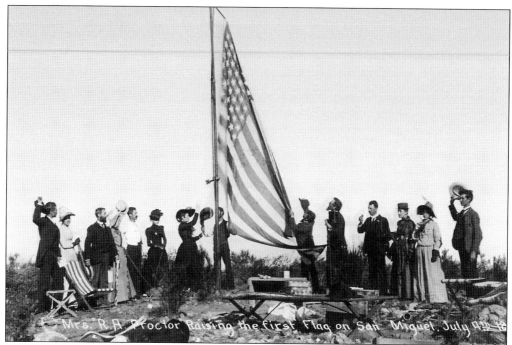

PROCTOR PARTY ON MOUNT MIGUEL, JULY 4, 1890. In early 1890, National City businessman Alfred Isham and his partner H.L. Story, Hotel del Coronado co-owner, announced plans for an elaborate observatory, hotel, and pavilion on Mount San Miguel. The widow (left of flag) joins in this promotional Independence Day event at the mountain's summit. (San Diego History Center.)

ISHAM'S SPRINGS, C. 1910. The San Miguel observatory plans were doomed, but Alfred Isham quickly moved his focus across Sweetwater Reservoir to the springs located near the intersections of today's Jamacha and Sweetwater Springs Roads. Isham's "California Waters of Life" sales brought initial fame and fortune. His claims of miraculous curative powers were debunked publicly in 1906, leading to Isham's eventual disgrace and the enterprise's failure. (San Diego History Center.)

Two

A COLONY FOR ARTISTS
1902–1917

By the turn of the 19th century, the area around Mount Helix had been established in the agricultural-based rural communities of Spring Valley, Jamacha, La Mesa Springs (downtown La Mesa), Lemon Grove, and El Cajon. All had a few businesses, at least one church, and a community schoolhouse. The SDCE railroad served Lemon Grove, Spring Valley, La Mesa Springs, Alta Ranch, and El Cajon directly with stations and regular service. County "highways," including the Chollas or Cajon Road and its alternative route over the mesa (now El Cajon Boulevard), wound through Alta Pass and onto the El Cajon Valley. The county's federal road connected San Diego with Lemon Grove, Spring Valley, and Jamacha before crossing the Sweetwater River and traveling south to Jamul and points east. The San Diego Flume Company serviced the region's water needs from its flume line and storage reservoirs west of Hervey Parke's Alta Ranch (Eucalyptus Reservoir) and at the La Mesa Reservoir (now Lake Murray). Allison's Spring Valley and Lemon Grove flume followed the west face of Mount Helix and fed water to those communities. Yet it would take young entrepreneur Ed Fletcher to bring a new vision. The Massachusetts native's initial work as a produce merchant had allowed him to travel the county. Fletcher recognized that with reliable water and good roads, the agricultural hinterlands could be made profitable. When Hervey Parke died in 1899, the Alta Ranch properties became available for a reduced price. Fletcher showed interest in acquiring the ranch but initially did not have the funds. Coincidentally, on a return visit to Massachusetts, Fletcher stopped at Yellowstone National Park. Here, he met East Coast producer and well-known actor William Gross. Fletcher's description of San Diego's investment opportunities intrigued Gross. Their subsequent 1902 purchase and initial development of the property, renamed Grossmont, along with Fletcher's subsequent partnership with Montana investor James Murray, would set the stage for a new, and somewhat artistic, vision of rural suburban development for the rocky lands in between and around Mount Helix.

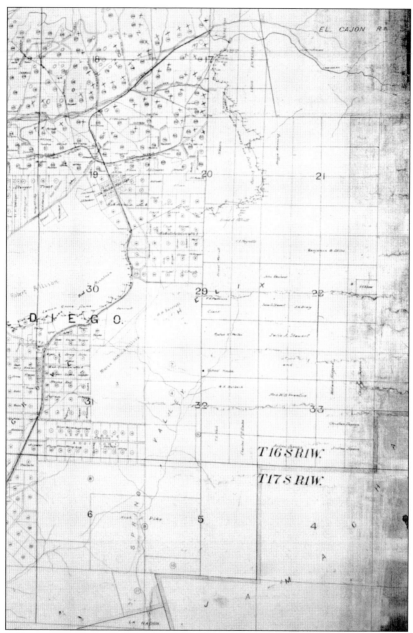

SAN DIEGO FLUME COMPANY SERVICE MAP, C. 1900. The Flume Company's building of a complex system featuring miles of wooden flumes, numerous tunnels, and storage facilities had taxed their resources. When an extended drought (1897–1904) made it difficult to supply existing customers, the company fell into receivership to English creditors in 1899, creating a challenge to regional development. Mount Helix is in Section 21. The SDCE railroad is the dark line rising from the lower left of the image. It passes through La Mesa Springs in Section 19, then makes its right turn to go over the Alta Pass and down into El Cajon. Allison's Lemon Grove and Spring Valley Flume line travels south from the Eucalyptus Reservoir in Section 17, through the future Grossmont area, and skirts the western slope of Mount Helix before heading west through lower Section 20. Spring Valley's Bancroft Ranch is in the southwest quarter of Section 29.

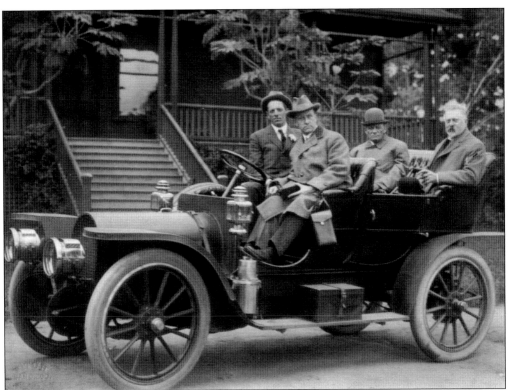

**FLETCHER AND GROSS AT VILLA CARO,
c. 1908.** Ed Fletcher's (left) and William
Gross's (far right) new property—
including the Villa Caro ranch house
seen here—appeared to have great
development potential. Resisting naming
the highest peak on the land Mount
Gross, the business partners platted
the original Grossmont subdivision in
1906, re-subdividing into the current
Grossmont Park tracts in 1908 and 1910.

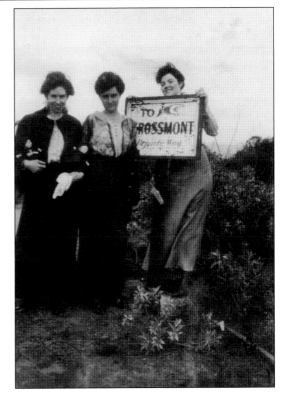

PROMOTING GROSSMONT, 1910. Here,
lovely lasses, including Zelda Heink-
Vernier (left) and Thelma Todd (right),
help promote the new tract (the woman
in the center is unidentified). Although
surveying lots and cutting roads into the
rocky hills on the south side of renamed
Grossmont Pass had begun, only a small
cottage for Gross had been started.
Soon, a series of Gross's entertainment-
industry acquaintances would trigger
further promotional excitement.

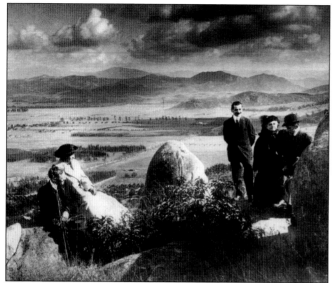

GROSSMONT "COLONISTS" AT THE CAPE HORN OVERLOOK, 1913. In late 1909, Grossmont attracted significant attention when famed composer Carrie Jacobs Bond, music critic Havrah Hubbard, and world-renowned opera star Madame Ernestine Schumann-Heink announced intentions for Grossmont residence. German soprano Johanna Gadski (at left, next to Fletcher) and Venezuelan pianist Theresa Carreno (right) soon announced similar intentions. Fletcher rapidly promoted the tract as a utopian artists' colony.

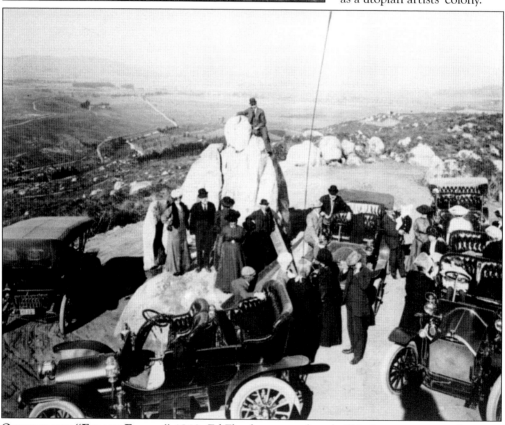

OPENING THE "FREAKY FLIGHT," 1913. Ed Fletcher seemed to thrill in having steep and narrow roads cut into Grossmont's rocky terrain. This typically precarious road built to Grossmont Peak opened in 1913 to much fanfare, especially when noted American singer and actress Lillian Russell drove her own automobile to the summit, noted by the local papers as "Freaky Fletcher's Frantic Flight" of a road.

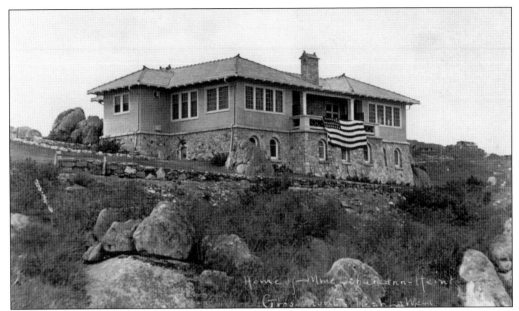

SCHUMANN-HEINK HOUSE, C. 1914. Although William Gross's cottage was the first start to start construction, the first to be completed was that of Madame Ernestine Schumann-Heink, the Austrian-born opera star. In August 1912, her Casa Ernestina was the first "artist colony" home competed. San Diego architect Del Harris designed this melding of Arts and Crafts rustic styling with modern 1910s amenities.

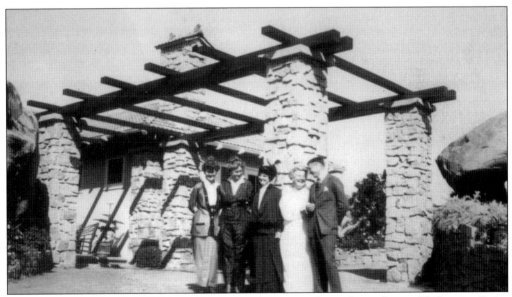

MADAME, FAMILY, AND FRIENDS, 1915. Located on a northeast-facing lot on El Granito Drive near Cape Horn, Harris's use of local cut stone and heavy beams on details such as this porte cochere reflected the latest architectural styles. Pictured here are, from left to right, Schumann-Heink's daughter Marie Guy, Grace Bolton, Thelma Todd, Schumann-Heink, and her son-in-law Hubert Guy. (Guy collection.)

31

CARRIE JACOBS BOND'S "NEST-O-REST," C. 1915. One of the next homes completed was that of composer and lyricist Carrie Jacob Bond, located next to the Grossmont Peak summit. Her home was a classic Craftsman-style three-room bungalow that she used for weekend getaways and entertaining. Bond solidified her promotion of Grossmont's idyllic qualities through the song and poem "A Cottage in God's Garden."

HAVRAH HUBBARD'S "LODGEHOME," C. 1918. Entertainer and noted music critic Havrah Hubbard, a longtime friend of William Gross, constructed a small redwood cottage atop one of Grossmont's large granite boulders. He epitomized the artist colony lifestyle when he built a small outdoor stage behind it. Hubbard later wrote for the *San Diego Union* and was involved in many local causes until his 1951 death. (Guy collection.)

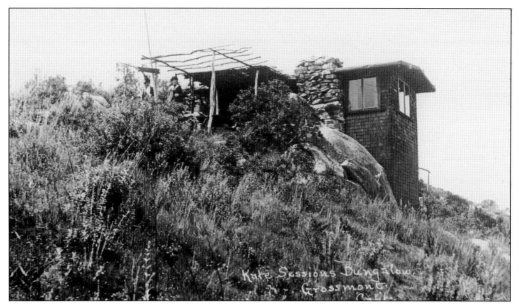

KATE SESSIONS HOUSE, C. 1918. Although not an entertainer, San Diego's noted horticulturist Kate Sessions built a redwood shingled bungalow at Grossmont. Session's renown as San Diego's landscape specialist inspired Fletcher to provide her with a house lot where this cottage was constructed and several acres for a nursery, sometimes known as "Sessions' Rose Garden plot."

LT. J.E. LEWIS HOUSE, C. 1915. Lt. J.E. Lewis and his accomplished violinist wife were early residents and built this Modern-style home typical of the new progressive ideals inspiring many Grossmont residents. Other noted Grossmont artist residents included poet John Vance Cheney and baritone Charles William Clark. Unfortunately, Johanna Gadski and Theresa Carreno passed away before building Grossmont homes.

33

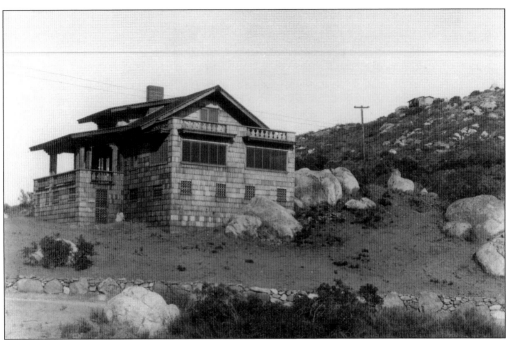

OWEN WISTER HOUSE AND RANCH, C. 1915. Perhaps the most famous Grossmont investor was American author Owen Wister. Wister's 1902 novel *The Virginian* is considered an American literary classic that established the American cowboy as a cultural icon. Fletcher met Wister in 1914, and he started construction of this shingle-clad bungalow the next year. Wister also had much of his land cleared and a large orchard planted. Fletcher capitalized on the novel's popularity and named several streets on the tract's west end in honor of it: Wister Drive, Virginian Lane, and Mollywoods Avenue. Wister had hoped to retire here, but the unexpected death of his wife changed his plans. Although he visited the area several times, he had Fletcher sell off his Grossmont and San Diego investments. (Both, Guy collection.)

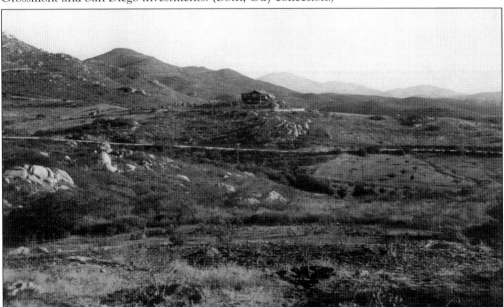

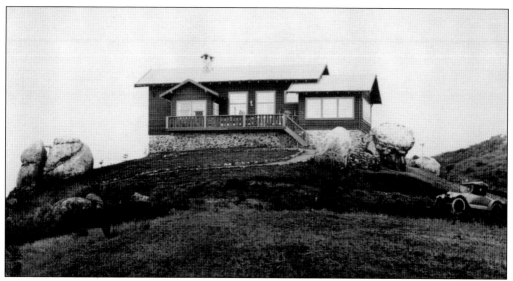

GUY COTTAGE, C. 1915. At her daughter Marie Schumann's announced marriage to Hubert Guy in 1915, Madame Schumann-Heink gave the couple an acre of land for building this Valle Vista Drive home. The Guys designed this 3,000-square-foot seven-room home themselves. The home had a Swiss chalet styling with unique Arts and Crafts elements, cathedral ceilings, and modern features such as a sunken living room. Typical of many Grossmont Colony homes, the redwood building sat on a large granite block foundation cut from local stone. The interior's ode to Southwestern influence melded with the Arts and Crafts infatuation with natural and native elements, reflecting the colony's promoted and practiced indoor-outdoor lifestyle.

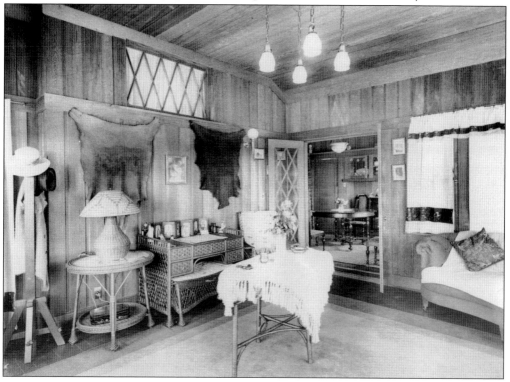

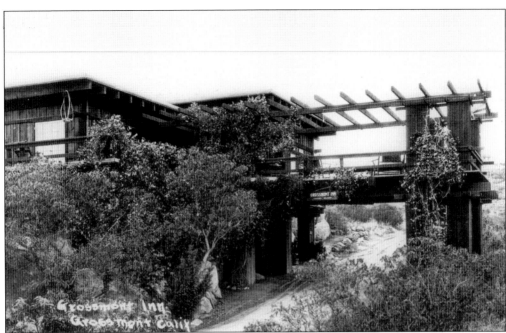

GROSSMONT INN, C. 1915. Ed Fletcher and his large family had lived in the Villa Caro ranch house since 1902. When planning a new residence on Grossmont, he also recognized the need for entertaining prospective purchasers and visitors. Fletcher engaged San Diego architect Emmor Brooke Weaver to design the resulting Grossmont Inn. Weaver would also design several other Grossmont homes. Completed in 1913, the Grossmont Inn, located on the road to the summit, became a showplace attraction. White-gloved staff greeted visitors who arrived at the porte cochere entrance, from which they were led to the upper porch, where tea and sundries were served. A few years later, former New York restaurateur Grace Sperry Godwin took over operation of the inn, for years renowned "as a place for interesting and interested people." (Both, Guy collection.)

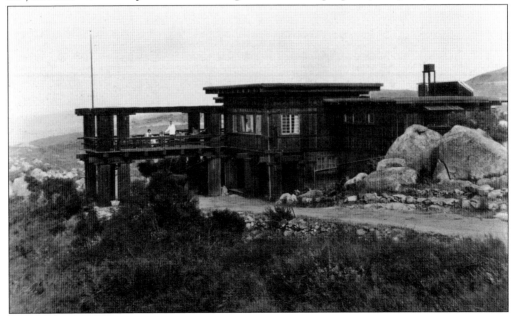

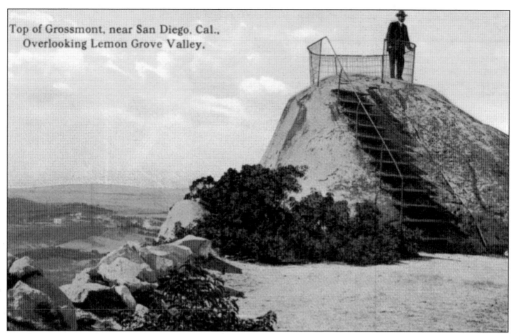

GROSSMONT PEAK, C. 1913. Fletcher's other developed attraction was Grossmont Peak. Taking one's motorcar up the precarious road to visit the pinnacle rock and climb the steep stairs to the 360-degree view was a popular outing. Fletcher's original tract listed this lot as a public "park," and this postcard image indicates the distinctive vantage achievable for all visitors.

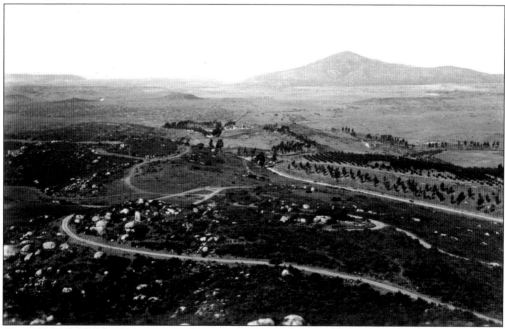

GROSSMONT FROM MOUNT HELIX, C. 1915. The still mostly undeveloped Grossmont is clear in this view northwest from Mount Helix. Eucalyptus Reservoir is at center left (now Briercrest Park) with the remaining orchards of Parke's Alta Ranch at center right. Cowles (pronounced Coals) Mountain is at upper right.

GROSSMONT STATION, 1915. The SDCE replaced the Alta Station with this renamed vine-covered building. Those wishing to visit the colony to examine lots or make a visit without means of transport could arrange for local resident Dan McFall and his horse-drawn surrey to meet them at the station and get a ride to the inn or peak. (Guy collection.)

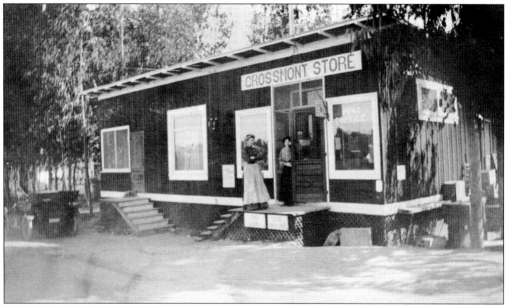

GROSSMONT STORE, C. 1911. With no school or church, the Grossmont Store and post office became a community center during the early days. The store was located along the newly designated state highway route that allowed the growing number of automobile travelers to cross through the rocky pass easily. (El Cajon Historical Society.)

VIEW TOWARD GROSSMONT FROM BRIAR TRACT, 1915. This image looks back toward Grossmont from the former Alta Ranch property to the north. Eucalyptus Reservoir is at center right with the ranch's orchards that still produced the popular Alta lemons spreading to the east. Although Grossmont was established, only a few dozen homes dot the arid rocky hills.

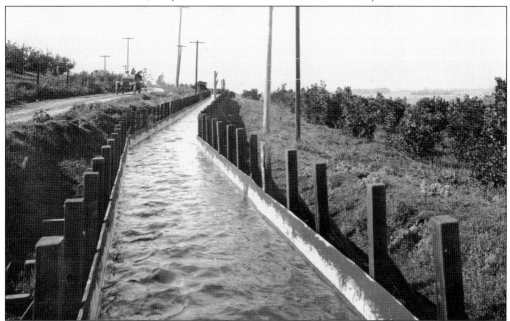

CUYAMACA WATER COMPANY FLUME, C. 1910. Fletcher recognized that water was the key to his development's success. With the San Diego Flume Company in receivership, the unaddressed deferred maintenance of the 20-year old system of wooden flumes was a legitimate concern. As such, he partnered with Montana capitalist James Murray to purchase the system, renaming it the Cuyamaca Water Company. (El Cajon Historical Society.)

MURRAY'S WALL, GROSSMONT PASS, C. 1910. Murray also obtained the land north of the railroad—later to become Fletcher Hills. He re-subdivided the land as Murray Hill and improved the old Alta Ranch property with this house and the wall that separated it from the state highway. Grossmont Station and the Hazard-Gould store can be seen at far right.

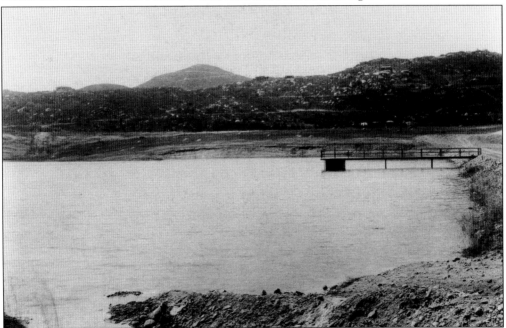

MURRAY HILL RESERVOIR, C. 1915. Murray not only provided most of the purchase funding but also capital for improving and maintaining the dilapidated system. One of the most important improvements for his and Fletcher's properties was to develop additional system storage with the 1911 construction of the Murray Hill Reservoir (now located below Harry Griffin Park).

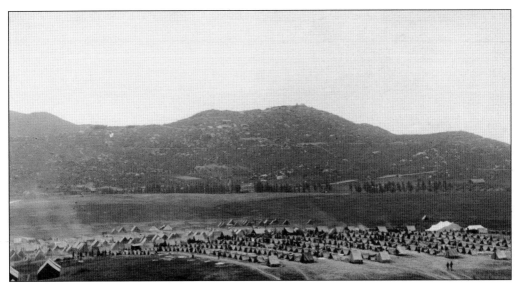

CAMP GROSSMONT, APRIL 1911. Local excitement in 1911 included the Mexican Revolution's expansion into northern Baja California. US troops from Northern California were sent to protect the border. As they needed training space, Fletcher, a former National Guard colonel, offered the Murray Hill land to the Army for this temporary training camp in April of that year. (El Cajon Historical Society.)

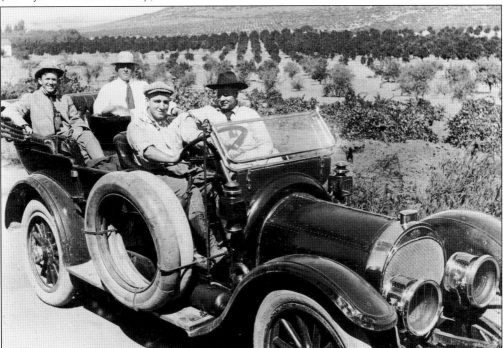

FLYING A FILM TROUPE ON LOCATION, 1911. Pioneering filmmakers of the American Film Company's "Flying A" troupe operated a downtown La Mesa studio (only the third in California) from August 1911 to June 1912. Here, director Allan Dwan (driver) and staff scout locations for one of the more than 100 one-reelers they produced while operating here. Dwan would go onto a prolific directing career in Hollywood.

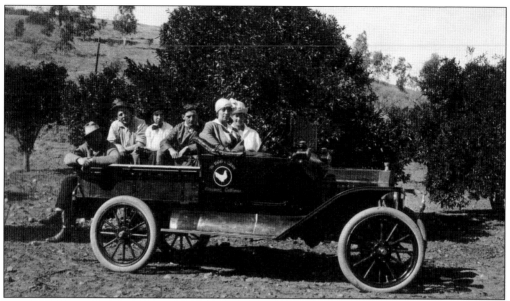

EGG PLANT FOR GROSSMONT, C. 1920. Hubert and Marie Guy also received 15 acres of former Villa Caro orchards as a wedding present. Hubert determined a better use would be for a poultry and egg ranch. Located near today's Chase and Pine Streets in El Cajon, Hubert Guy's Egg Plant preceded the region's later poultry-business success. Hubert is behind the front seat, Marie near steering wheel. (Guy collection.)

EL GRANITO MINERAL SPRINGS, C. 1910. The mineral springs on the old Chase Ranch were another notable attraction. Previous attempts at commercial water production had seen little success. In 1909, the name El Granito Springs was adopted and a resort planned. This instituted a period of moderate popularity and a 1920s soda pop business. The county destroyed the springs during construction of Avocado Boulevard.

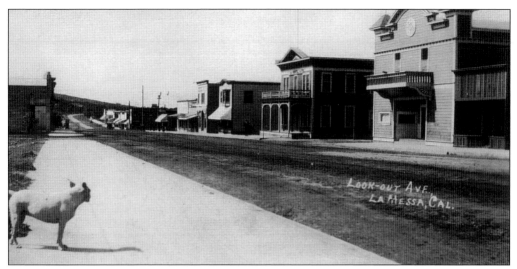

LOOKOUT AVENUE, LA MESA SPRINGS, C. 1910. While Fletcher and Gross established Grossmont, western neighbor La Mesa Springs grew and prospered. Starting in 1906, led by the Park-Grable Company, suburban and commercial development rapidly progressed. On February 16, 1912, in order to better control its destiny, the progressive community of some 700 citrus farmers, home-seekers, developers, and businessmen incorporated into the city of La Mesa.

LA MESA GRAMMAR SCHOOL, 1914. In 1912, with La Mesa and neighbor Spring Valley continuing to grow steadily, the Allison and Spring Valley School Districts merged. This also helped fund construction of this Richard Requa–designed modern Mission Revival–style grammar school that would serve as the only school for these communities for nearly three decades.

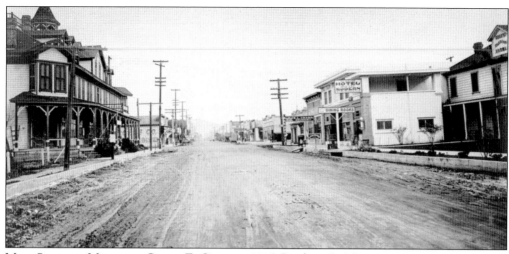

Main Street at Magnolia, City of El Cajon, c. 1915. Similar to La Mesa, community growth around Knox's Corners had steadily continued. By 1910, the community center, which featured the Corona Hotel (left foreground) and Knox's Hotel and Annex (right foreground), anchored a small commercial district. On November 12, 1912, El Cajon joined its western neighbor as an incorporated city.

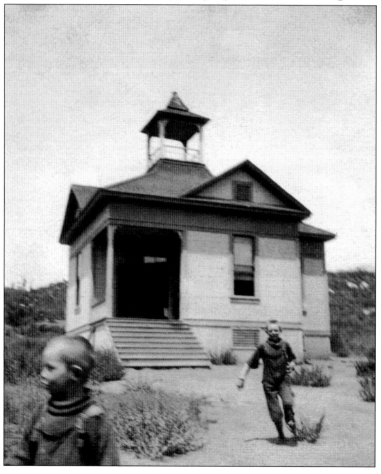

Hillsdale School, c. 1910. With roads improving and automobiles providing easier transport, the era of the remote single-room school, like the one at Hillsdale, was ending. The decline in the school's population forced closure in 1921, with all students transferred to El Cajon Grammar. The old schoolhouse still served the community as a meeting place in the ensuing decades. (El Cajon Historical Society.)

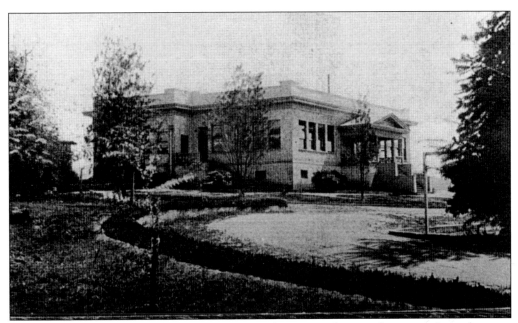

ORIGINAL EL CAJON VALLEY HIGH, C. 1910. Local concerns for providing secondary education resulted in the creation of the original El Cajon Valley High in 1894. The union high school district shared the Meridian School site in Bostonia until this new concrete building was completed in 1908. Lakeside residents would create their own Riverview High in 1916. Unfortunately, neither would meet the ultimate regional demand. (Cajon Valley School District.)

LEMON GROVE PACKINGHOUSE, C. 1910s. Although La Mesa and El Cajon were slowly suburbanizing, the communities around Mount Helix continued to rely on their agricultural roots. Packinghouses in El Cajon, La Mesa, and Lemon Grove (pictured) served local ranchers and farmers in the 1910s. However, the trends in agriculture in the next decades would eventually work against the small independent farmer.

MARIPOSA AVENUE BUNGALOW, C. 1914. Bungalow ranch homes like this one, located west of Mount Helix and Eucalyptus Park, were a common part of the rural landscape. This shot with the hills of Spring Valley to the south (including Dictionary Hill at right, so named for an encyclopedia company's promotional campaign) represents the region's dominating rural nature of a century ago.

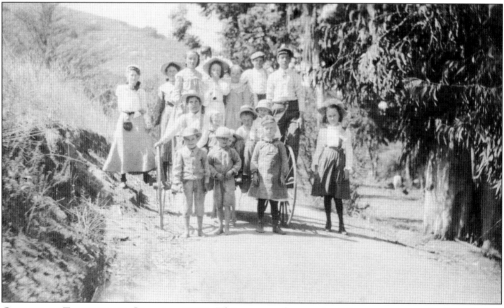

OUTING AT EUCALYPTUS CANYON, 1912. This group of young La Mesans poses at the Eucalyptus Canyon grove on Bancroft Road, connecting Spring Valley with Mount Helix and Grossmont to the north. After the end of the World War I, the community spirit of these small, mainly rural communities would be tested as modern life and new commercial ventures brought opportunity and progress.

Three

CEMENTING A COMMUNITY LANDMARK
1917–1928

As the United States entered World War I, the region around Mount Helix was still a small rural community of a few thousand residents. Yet the civic and business leaders of the area retained great visions for its future development. Ed Fletcher was at the core of this future vision. In 1916, Fletcher obtained title to undeveloped Mount Helix. In the meantime, Fletcher was occupied with lawsuits over rights to the San Diego River's water that threatened the future autonomy of the Cuyamaca Water Company—and the region. Subsequently, his Mount Helix development plans became secondary. But never missing a promotional opportunity, he looked to draw attention to his new property. In 1917, Fletcher offered the peak as the new venue for a growing community event, an Easter Sunday sunrise service on La Mesa's Mount Nebo that was outgrowing its original location. Starting Easter morning on April 8, 1917, Mount Helix became the scene of this annual community celebration. It was serendipitous that Mary Carpenter Yawkey was one of the growing numbers of visitors to one of these early Mount Helix services. The mother-in-law to San Diego lumber merchant and Helix coinvestor Fred White, Yawkey had been inspired by her experience at the mountaintop community event. After her passing in 1923, her daughter Mary Yawkey White and lumber magnate son Cyrus Yawkey, both cousins of Boston Red Sox owner Tom Yawkey, proposed to construct a memorial theater at the summit to honor their mother. Opened in time for the Easter service of 1925, this landmark was subsequently donated to the county as trustee for holding this annual event and to serve as a public park. The Yawkeys' generous and community-minded efforts have proven to be the cement that has reformed this natural landmark into a permanent cultural resource and set the foundation for a truly visionary future for the Mount Helix community.

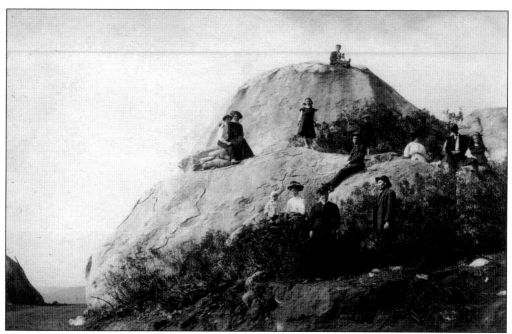

MOUNT HELIX VISITORS, 1910S. County tax records indicated speculative owners of Mount Helix throughout the 1890s. Yet, in 1913, the plats showed no formal owner. Still, a rough trail had previously been cut to the peak to allow visitors, such as those seen here, to ascend or, as this post-captioned postcard notes, drive a wagon or automobile up the precipitous route to the summit.

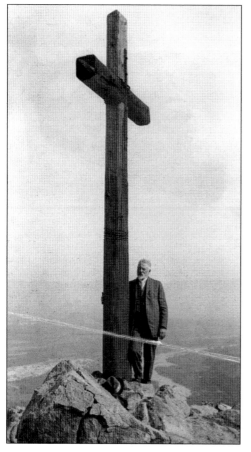

WILLIAM GROSS AT MOUNT HELIX CROSS, c. 1918. Although William Gross had profited from his Grossmont investment, he declined to invest in Ed Fletcher's Mount Helix property. He continued to provide his promotional support, such as this photograph of him, and the original wooden cross that Fletcher erected on the peak for the annual Easter services.

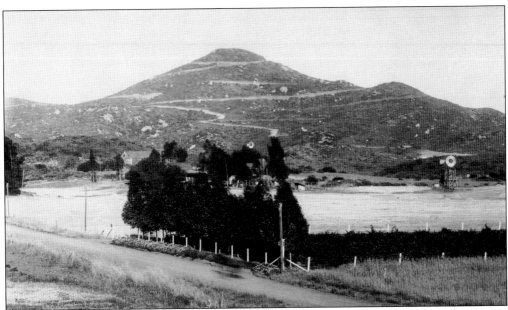

SWITCHBACK PATHS UP HELIX, C. 1918. This view shows the rough dirt roads and trails that provided initial access to the peak. In order to accommodate the Easter services, Fletcher had the original pathways widened, brush and rock cleared at the summit, and the aforementioned Christian cross erected at the peak.

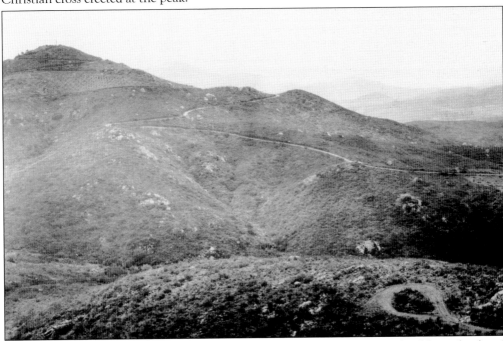

MOUNT HELIX FROM GROSSMONT, C. 1918. This unique view displays a rare angle of the undeveloped northern face of Mount Helix and the original summit route. In the next decade, the La Mesa, Lemon Grove and Spring Valley Irrigation District, which purchased the Cuyamaca Water Company in 1926, would construct the Helix Lake storage reservoir in the canyon below. (El Cajon Historical Society.)

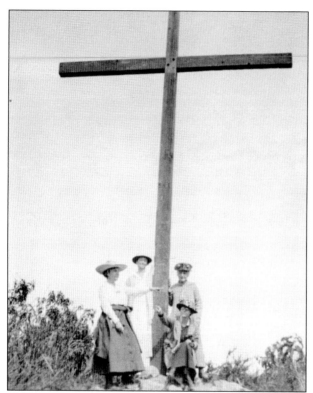

VISITORS TO HELIX CROSS, 1920. As the road to the summit was improved, Mount Helix joined Grossmont Peak as a popular attraction for automobile excursionists looking for a special road trip. Here, four sojourning ladies pose at the already well-known Mount Helix cross. A companion photograph (not shown) of them in their automobile at the summit confirms their mode of ascendance to the peak.

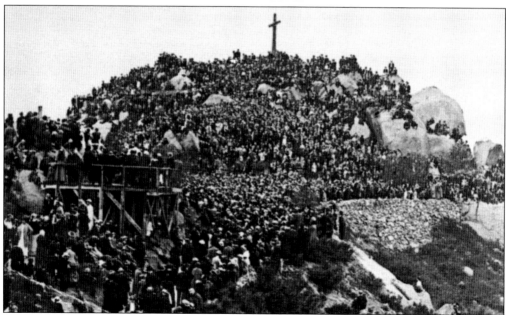

MOUNT HELIX EASTER SERVICE, C. 1922. This rare image of a pre-theater Mount Helix Easter Service illustrates the efforts required to produce and attend the event. A wooden platform had been erected to provide an altar for the reverends to administer the services. Those attendees that had traveled up in the early morning light were then scattered over the rocks and cleared spaces. (Guy collection.)

MARY CARPENTER YAWKEY AND SON CYRUS, C. 1920. Samuel and Mary Yawkeys' son Cyrus continued the family's lucrative lumber business, becoming the most financially successful branch of the Boston Red Sox–owning family. Mary Yawkey's enjoyment of the Mount Helix Easter service during a visit to her daughter Mary Yawkey White's San Diego home made quite an impression on her and her children.

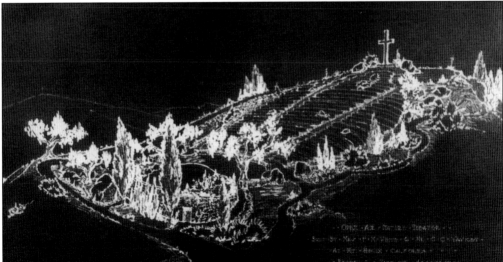

MT. HELIX NATURE THEATER PLAN, 1924. After Mary Carpenter Yawkey's death, her daughter Mary White and son Cyrus Yawkey proposed constructing an outdoor amphitheater for the Mount Helix Easter services in her honor. Fred and Mary White engaged the top architect in San Diego, Richard Requa, to design the theater. Requa's design integrates the native granite boulders and natural bowl on the east face into the nature theater.

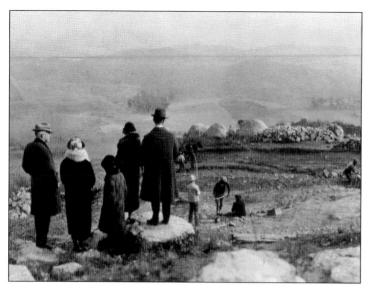

THE FLETCHERS AND FRIENDS WATCH THEATER CONSTRUCTION, 1924. Ed Fletcher worked closely with Fred and Mary White and Cyrus Yawkey to implement Requa's plan. Fletcher assigned his oldest son, Ed Jr., to oversee the construction. Horse teams with Fresno graders and Model T trucks supplemented the laborers.

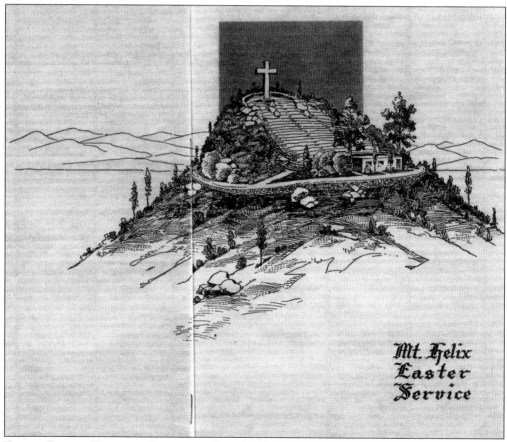

Mt. Helix
Easter
Service

EASTER SERVICE PROGRAM COVER, 1925. With diligence and dedication, the Mt. Helix Nature Theater was ready for the April 12, 1925, event. The Advertising Club of San Diego sponsored this well-publicized inaugural opening service. The *San Diego Union* reported that the new theater "appeared in the first light of day to have been hewn from solid rock."

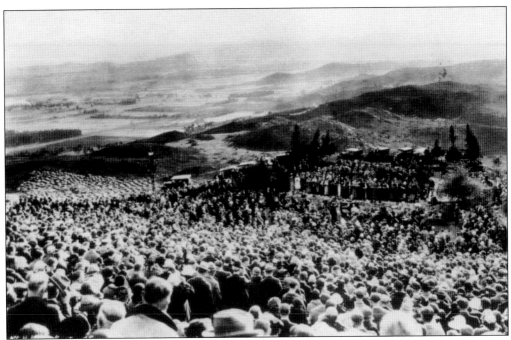

FIRST EASTER SERVICE AT HELIX THEATER, APRIL 12, 1925. Newspapers reported that 8,000 attended the inaugural event, "a triumphal celebration of the resurrection day" according to the *San Diego Union*. If those numbers were wholly accurate, it would have more than doubled the Mount Helix area's population for the day. These photographs indicate that the new theater was overflowing with attendees and the surrounding undeveloped hills were covered with parked automobiles. Those who attended were witnesses to what the *Union* lauded as "no more impressive or beautiful service on the mount could be conceived than the one held yesterday," a "mild night gave way to a bright dawn and an unclouded sunrise."

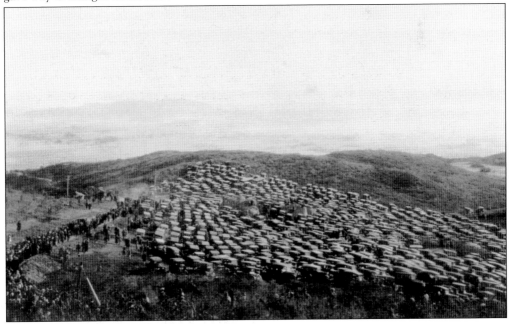

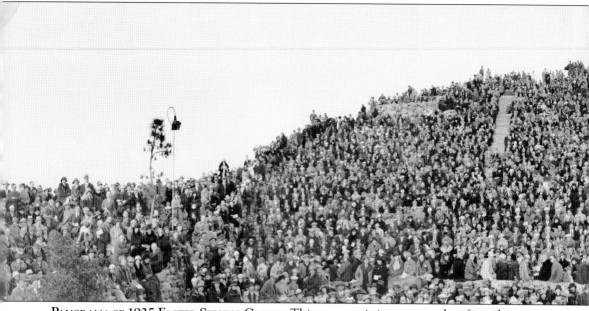

Panorama of 1925 Easter Service Crowd. This panoramic image was taken from the stage to capture the crowd. According to the newspaper reports, "The program proceeded according to schedule." As the first rays of light "crept over the mountains to the east and touched the great cross atop Mount Helix" at 5:23 a.m., conductor Nino Marcelli of the San Diego Oratorical Society

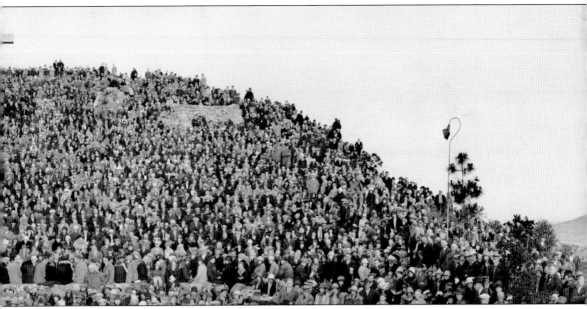

swung his baton, and the orchestra and chorus broke into Handel's "And the Glory of the Lord." When the crowd joined in, they sang with "a fervor born of the inspiration of the moment, and the stone walls of the amphitheatre gave volume and depth to the voices of the singers and the orchestral instruments."

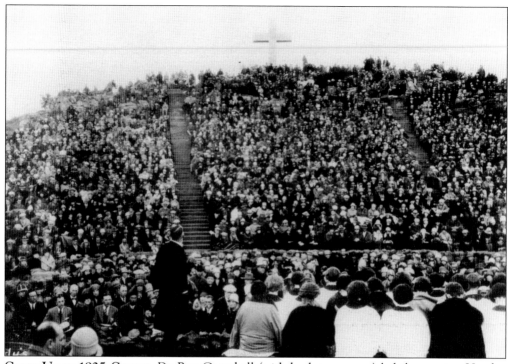

CLOSE-UP OF 1925 CROWD. Dr. Roy Campbell (with back to camera) led the service. He also thanked the ladies responsible (Mary Yawkey and Mary White). Campbell proclaimed, "It is fitting that this wonderful memorial on this mountain top, baptized this Easter morning with worship and praise, should be dedicated in the name of a women, a mother and friend. It is a testimonial of love."

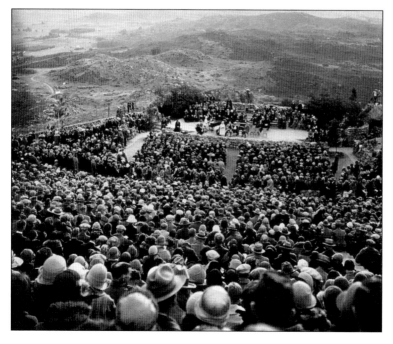

MOUNT HELIX EASTER SERVICE, 1926. The following year, the *Union* reported another crowd in the thousands had been brought to the theater. Notable was a local automobile dealer shuttling "ambulatory" persons up to the service. San Diego Naval Station chaplain Frank H. Lash delivered the invocation, and despite cold weather and the threat of rain, the tradition was cemented.

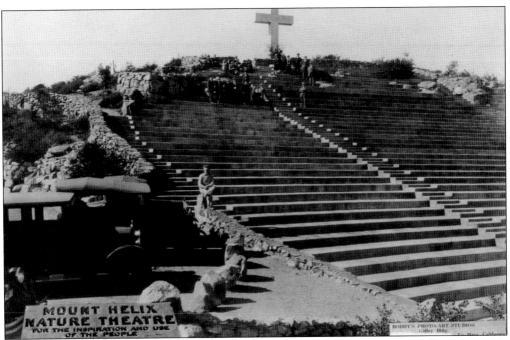

INSPIRATIONAL MT. HELIX NATURE THEATER, 1928. The Mt. Helix Nature Theater quickly became a local icon and attraction. Soon, the La Mesa–El Cajon–Spring Valley region was counting the praises of their new asset. Many others saw opportunities for additional events. In 1927 and 1928, local developer Fred Hansen, Grossmont resident Havrah Hubbard, and others sponsored a Sunday before Thanksgiving sunset service. Low attendance in the first year and the coming of the Great Depression ended the attempt at creating a second annual community event. Similar early attempts at holding theatrical performances also fell short of expectations. Still, the open-to-the-public park-like nature theater made it a popular spot for locals and visitors, whether large crowds, families, or individuals.

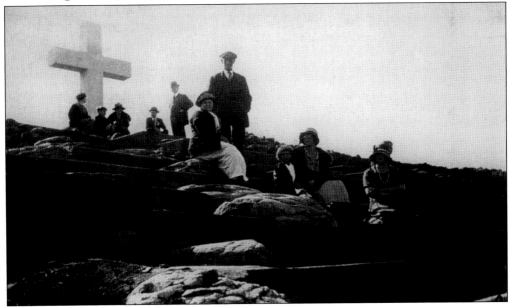

SALE OF CUYAMACA WATER COMPANY, JANUARY 4, 1926. In 1925, irrigation district residents passed a $2.5-million bond to acquire the Cuyamaca Water Company. Here, Ed Fletcher receives the check confirming the sale. The district's 1932 agreement to sell Lake Murray and the El Capitan dam site to the City of San Diego settled long-standing lawsuits and resulted in guaranteed water for the Mount Helix region.

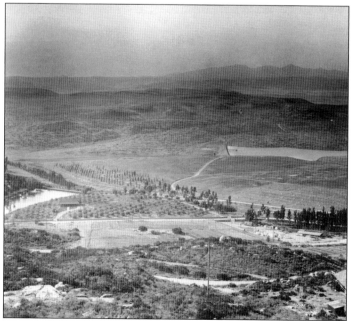

VIEW NORTH FROM GROSSMONT PEAK, c. 1922. This view north from Grossmont Peak clearly identifies the spring-fed Alta lotus pond (now part of Anthony's Restaurant) at center left. Murray Hill Reservoir is in the upper right, and a small construction camp is located at lower right. The camp was likely overseeing the quarrying of local Grossmont stone and the building of the region's newest educational institution. (El Cajon Historical Society.)

GROSSMONT HIGH SCHOOL, C. 1923, AND TRAPNEST STATION LETTERHEAD, C. 1927. East County's interest in providing secondary education was complicated. The two small high schools, Bostonia's El Cajon Valley and Lakeside's Riverview were both struggling to meet the growing demand, while still not servicing La Mesa, Lemon Grove, Spring Valley, or Jamacha students. In 1920, the two small high schools merged into the renamed Grossmont Union High School District, Ed Fletcher being an important catalyst once again. Fletcher donated both stone from quarries on his Grossmont property and the acreage north of the SDCE station for the school site. In September 1922, after two long years of construction, the new Grossmont High campus opened. It quickly became an invaluable community asset, particularly its popular agricultural programs such as the state-sponsored poultry trapnest station.

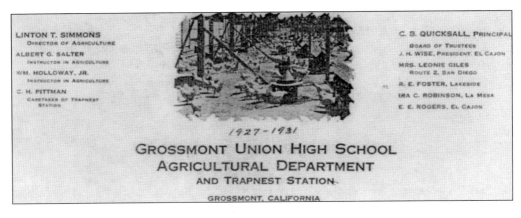

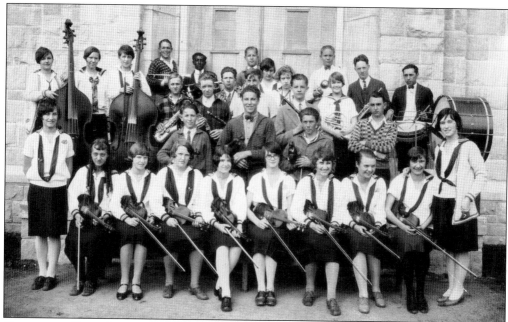

GROSSMONT HIGH ORCHESTRA, 1927, AND BASEBALL TEAM, 1926. In addition to its academic prowess, Grossmont provided programs that added social and civic benefits regionally. Locals found pride and entertainment in the school's band and orchestra along with theatrical performances. Athletics also proved to be a rallying point for the East County community. Baseball, which had been a local staple since the 1890s, was one of the more popular sports, as they completed with other small county high schools such as rivals Sweetwater, Escondido, Oceanside, and Coronado and the new suburban schools such as Point Loma and La Jolla. Basketball and football also proved competitive, including the 1926 football team that won the Southern California small-school championship.

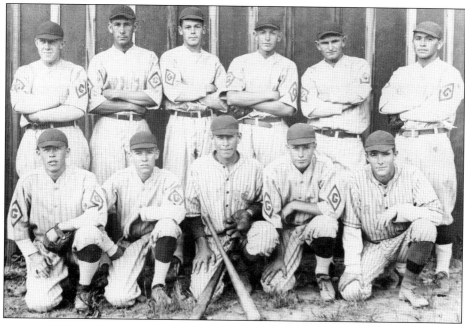

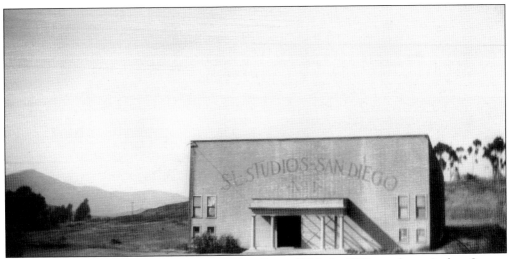

S-L STUDIOS, 1922, AND GROSSMONT STUDIO CAST, 1925. In 1922, producer Arthur Sawyer approached Ed Fletcher about building a movie studio at Grossmont. Sawyer's S-L Studios were constructed west of the lotus pond. Unfortunately, other than the studio building, the company's operations did not progress. Fletcher and other local investors took control and reorganized it into Grossmont Studios in 1925. Grossmont built several new sets, including a large Egyptian scene that many locals later recalled. Although still images exist, including this one from a film called *Beloved Bandit*, the studio's work, as with many silent-era movies, has disappeared. The company shut down operations by 1928, and the studio building was leased out as a roller rink and nightclub until destroyed in a 1934 fire.

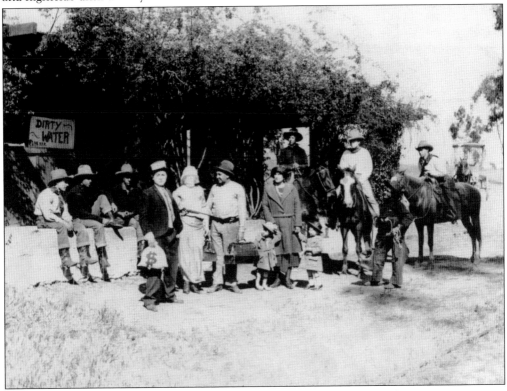

LA MESA COUNTRY CLUB, C. 1928. Located on the small hill south of today's Highway 125 and 94 intersection, the La Mesa Country Club opened as a nine-hole dirt fairway course in 1921. Investors' plans included the subdivision of the hill and land to the east, instituting Kenwood and Kenora Drives as an exclusive country club community. In 1928, the club hired architect Richard Requa to redesign a former Bancroft Ranch building at the hilltop into a clubhouse with dining hall and ballroom (below). The course was expanded to 18 holes, and the fairways were turfed in 1929. The clubhouse was a popular venue for community events. In 1950, the Brookside Development Company purchased the course property for houses, and the clubhouse was sold to the Trinity Lutheran Church.

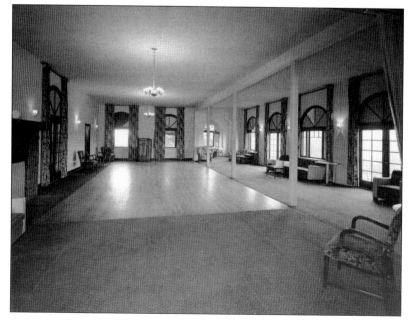

LA MESA'S EVERGREEN CEMETERY MAP, C. 1920. In 1914, La Mesans established the Evergreen Park Cemetery on 20 acres located northeast of the Bancroft Road and Lemon Avenue intersection. Although 75 burials had occurred, concerns over the cemetery's condition in the 1920s led a development syndicate to purchase the property. The new owners relocated the burials to San Diego's Glen Abbey Cemetery in 1926, opening the land for development.

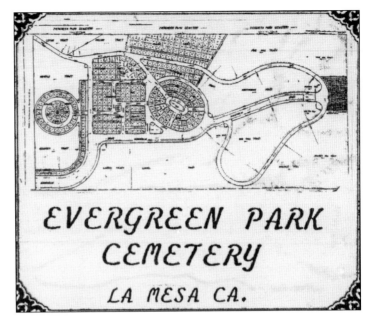

FRED HANSON HOUSE, C. 1925. Fred Hansen was one of those developers. Hansen had made his fortune working for the Illinois Cyclone Fence Company before moving to San Diego in 1924. Intrigued by the potential of the Helix area, he would build this beautiful Brittany Spanish–style home and avocado orchard off the recently opened Fuerte Boulevard in 1925, establishing the pattern for his future development plans.

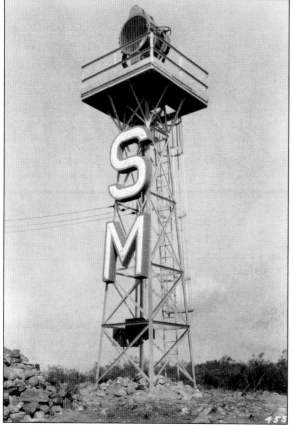

EUCALYPTUS PARK, C. 1928. By 1928, La Jolla resident and Grossmont homeowner Walter Lieber obtained Charles Crosby's old Eucalyptus Canyon grove property. Recognizing the grove's value to the community, on Christmas day in 1929, he donated it for a county park. The La Mesa Chamber of Commerce honored Lieber's generous action with a dedication event on July 4, 1930.

MOUNT MIGUEL STANDARD AVIATION BEACON, C. 1928. As the 1920s came to a close, the region's interest in and expansion of aviation grew. It was at this time that the department of commerce erected this long-serving landmark at the top of Mount San Miguel, signaling the coming of modern life to the rural area.

Four

THE AVOCADO IS
KING—AND QUEEN
1928–1945

The Roaring Twenties were memorable for their entrepreneurial spirit and flamboyance. In Southern California, the mid-1920s saw another real estate boom result in steady growth in commerce and population. One of those attracted to speculative opportunities at Mount Helix was the aforementioned Fred J. Hansen. A Danish immigrant who had moved to Illinois at age 10, he had made a fortune in the cyclone (chain-link) fence business before moving to San Diego County. He chose this place for his second career and home because there was "no spot so exactly suited for a country estate more than Mount Helix." And what he considered the key element in converting the area into gentlemen's ranch estates was avocados. Hansen was inspired by the statewide cooperative California Avocado Association and the Calavo Growers of California and their efforts to market more palatable varieties. Hansen quickly moved to make the once-mocked alligator pear into Mount Helix's "green gold." Taking advantage of Ed Fletcher's cutting of a new direct road (Fuerte Drive) across the Grossmont tracts to open access to the east side of Mount Helix and the subsequent Lemon Avenue extension in 1924, Hansen purchased considerable tracts of land. In 1927, the Evergreen Cemetery property became Hansen's Avocado Villas. Hansen subdivided the land to the east of Mount Helix as Calavo Gardens in 1928. He would also purchase land south of Campo Road, including the former Isham Springs land in Sweetwater Springs. Others developers, including John Cornelius, would follow Hansen's lead, opening the Casa de Oro Avocado Estates on the south slope of Helix in 1929. Although the Great Depression would hamper full build-out of these unique rural suburban developments, by the 1930s, the Mount Helix area was a major contributor to making San Diego County the nation's avocado-industry leaders. Subsequently, the Mount Helix area would still have its agricultural roots intact as it rode out the changes brought to the region during and after World War II.

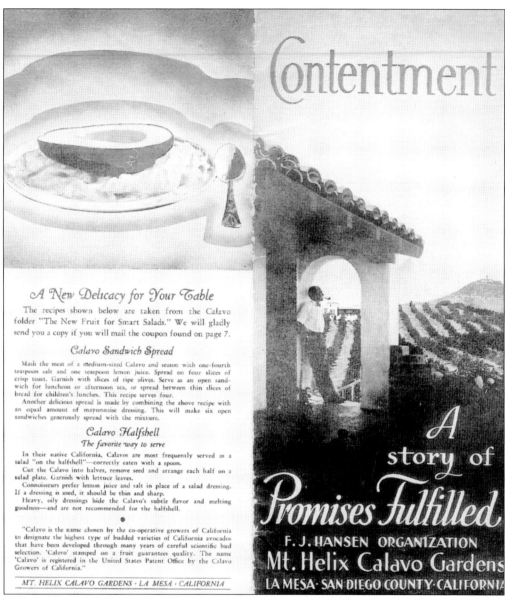

Contentment

A New Delicacy for Your Table

The recipes shown below are taken from the Calavo folder "The New Fruit for Smart Salads." We will gladly send you a copy if you will mail the coupon found on page 7.

Calavo Sandwich Spread

Mash the meat of a medium-sized Calavo and season with one-fourth teaspoon salt and one teaspoon lemon juice. Spread on four slices of crisp toast. Garnish with slices of ripe olives. Serve as an open sandwich for luncheon or afternoon tea, or spread between thin slices of bread for children's lunches. This recipe serves four.

Another delicious spread is made by combining the above recipe with an equal amount of mayonnaise dressing. This will make six open sandwiches generously spread with the mixture.

Calavo Halfshell
The favorite way to serve

In their native California, Calavos are most frequently served as a salad "on the halfshell"—correctly eaten with a spoon.

Cut the Calavo into halves, remove seed and arrange each half on a salad plate. Garnish with lettuce leaves.

Connoisseurs prefer lemon juice and salt in place of a salad dressing. If a dressing is used, it should be thin and sharp.

Heavy, oily dressings hide the Calavo's subtle flavor and melting goodness—and are not recommended for the halfshell.

•

"Calavo is the name chosen by the co-operative growers of California to designate the highest type of budded varieties of California avocados that have been developed through many years of careful scientific bud selection. 'Calavo' stamped on a fruit guarantees quality. The name 'Calavo' is registered in the United States Patent Office by the Calavo Growers of California."

MT. HELIX CALAVO GARDENS · LA MESA · CALIFORNIA

A story of Promises Fulfilled

F. J. HANSEN ORGANIZATION
Mt. Helix Calavo Gardens
LA MESA· SAN DIEGO COUNTY·CALIFORNIA

CALAVO GARDENS BROCHURE, C. 1928. This Calavo Garden promotional brochure cover introduces both the promises and values of the avocado tract community and the romantic California lifestyle being sold. Mount Helix and its iconic cross can be seen in the distance next to this Spanish Colonial Revival–style home. Calavo Gardens was sold to investors as a not-to-be missed opportunity for the ultimate rural suburban lifestyle. The theme was etched onto the landscape, with Fuerte Road being named for one of popular new avocado varieties. Hansen had the road extended east where the Calavo tract featured streets also named in the avocado theme, including Queen, Nabal, Puebla, Alta Rica, Itzama, Anaheim, Calavo, and the main north-south thoroughfare, Avocado Boulevard. Although the Great Depression slowed sales, a steady number of individuals purchased lots to build their own dream homes and plant avocados. Soon, gentlemen's avocado ranches were covering the previously rocky and undeveloped lands around Mount Helix—and making them profitable.

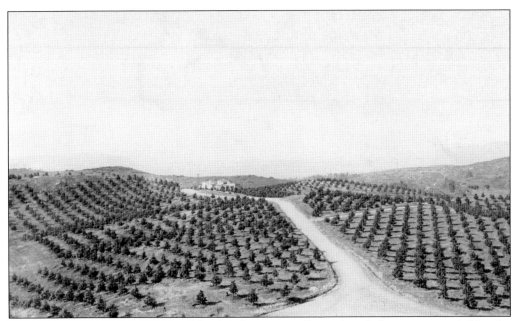

HELIX AVOCADO RANCH, 1920s. This Mediterranean Revival–style home surrounded by the sea of avocado trees was soon the norm for the Mount Helix area. Although avocados had been tried in the area since the early 1910s, the newer, tastier varieties produced through the Calavo cooperative widened the market. Hansen also promoted the crop by sponsoring informational workshops for local growers.

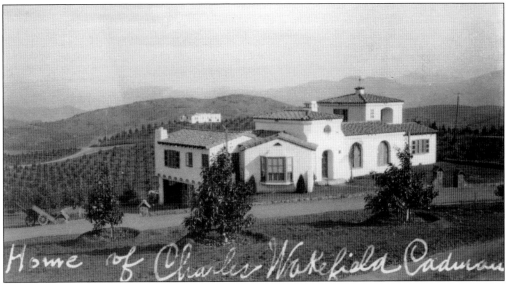

CHARLES CADMAN HOUSE, c. 1930. Similar to Grossmont, Hansen and the Mount Helix developers took advantage of well-known new residents. Here is the home and orchard of popular American composer Charles Wakefield Cadman. Cadman's beautiful Mediterranean Revival–style home was used regularly as a prototypical Helix gentlemen's ranch—reflective of the notable people living in the area.

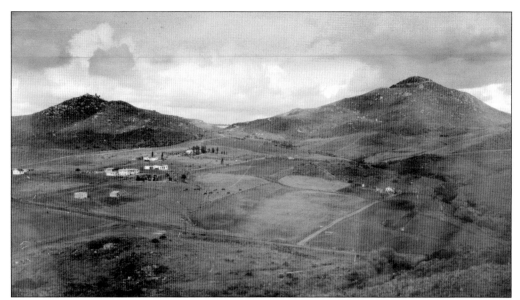

VIEW EAST TOWARD GROSSMONT AND HELIX, 1928 AND 1939. This image was shot from La Mesa Highlands looking east at Grossmont Peak and Mount Helix prior to significant development. Bancroft Drive is seen left to right across the foreground. Lemon Avenue, traveling along Grossmont's south base, now connected east to Fuerte Drive. The first few houses on the streets east of Bancroft represent early residential development. The lower image is taken from a similar perspective but a decade later. Clearly, the later view shows new orchards and houses, reflecting the popularity of the rural suburban lure of the Mount Helix area for home builders.

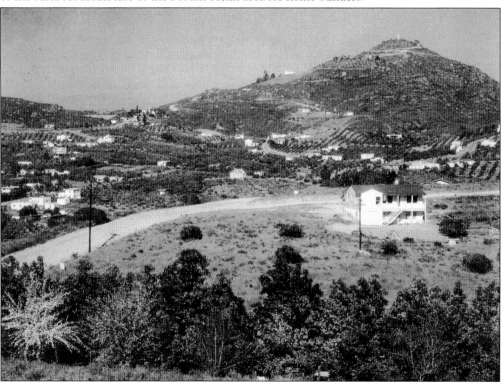

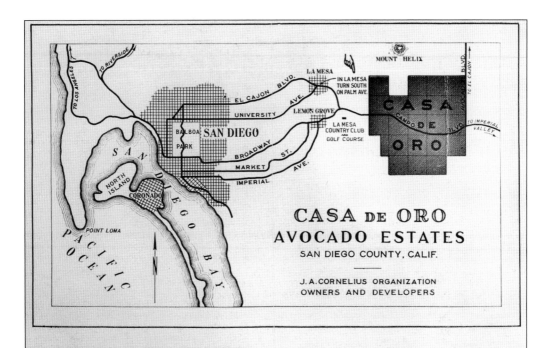

J. A. CORNELIUS ORGANIZATION

2500 W. 6th St. 802 B Street
Los Angeles, Calif. San Diego, Calif.

CASA DE ORO ADVERTISEMENT AND SUBDIVISION GATE, c. 1930. Los Angeles developer John Cornelius' Casa de Oro Avocado Estates followed Hansen's marketing lead. Located on the southern slopes of Mount Helix straddling Campo Road, Casa de Oro's 853 acres were mostly undeveloped at the time of this tract's 1929 opening. The former site of Peter Tomeney and Benjamin Stiles's 1880s citrus ranches, the rocky slopes had sat quietly. The Casa de Oro (house of gold) marketing campaigns sang the same magical tune of avocados turning lots into "green gold." Although the Great Depression would shut down Cornelius's operations and keep Casa de Oro awaiting significant development, a small business district formed along Campo Road, helping cement the community's moniker in the area. (Both, San Diego History Center.)

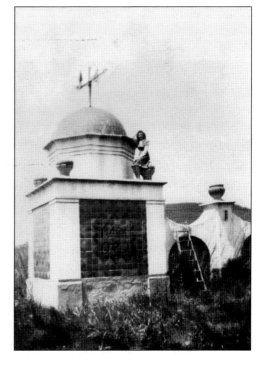

New Helix Avocado Orchards and Grossmount Tomatoes, c. 1930. As noted, Hansen and the Calavo organization provided regular support for their tract members and growers. Pamphlets, workshops, trainings, circulars, and cooperative marketing ventures helped grow the local industry's business—even during the Great Depression. As seen in the photograph below, the year-round production that avocados provided helped keep seasonal fields more productive, such as those producing the popular Grossmount brand tomatoes (see bushes below) along with the newly staked avocado trees. Grossmount (even misspelled) was a brand that local growers, including a small, but hardworking, group of Japanese tenant farmers joined.

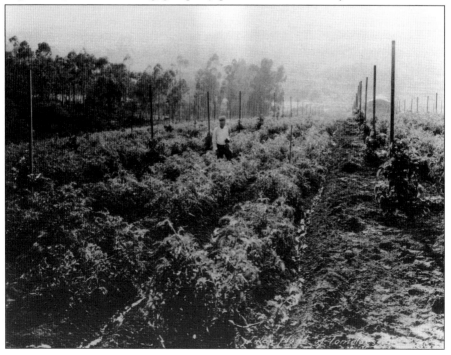

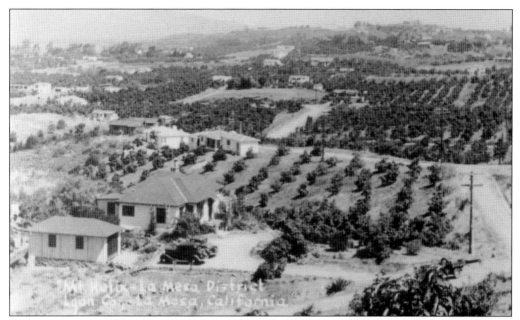

CALAVO AVOCADO "RANCHETTES," 1930S. Not all Calavo Garden ranchers built large Revival-style homes. Many built the popular minimal traditional type houses, such as those seen in this 1930s image. Although large show-place houses found at the Mount Helix "gentlemen's ranches" received much of the marketing attention, these homes represented the large number of family-based "ranchettes."

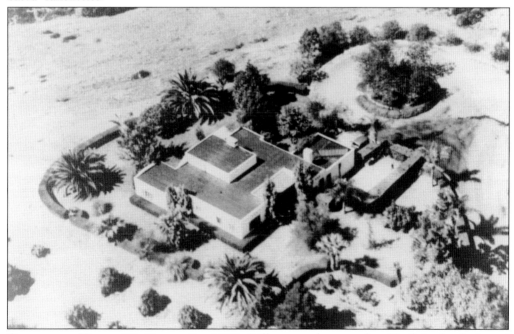

CARMICHAEL HOUSE, "EL TEJADO," C. 1930. Still, many who moved and built in the shadow of Mount Helix looked to the latest in designs. Bruce Carmichael and his wife, Gloria, were civic and society leaders in La Mesa. They had this Modern-style home built on the west slope of Mount Helix. Local architect/builder Theodore Clemensha designed this La Mesa historical landmark.

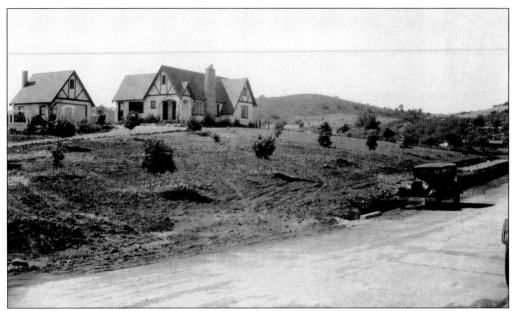

SAWYER HOUSE, C. 1928. Other Mount Helix home builders preferred the Revival-style homes typical of 1920s suburban dreams. Clifford and Jennie Sawyer chose Tudor Revival for their Helix home on Merritt Drive. The Kansas native and former Wyoming rancher brought his family to the area in 1927, purchased a lot, and built this house amid his new avocado orchard.

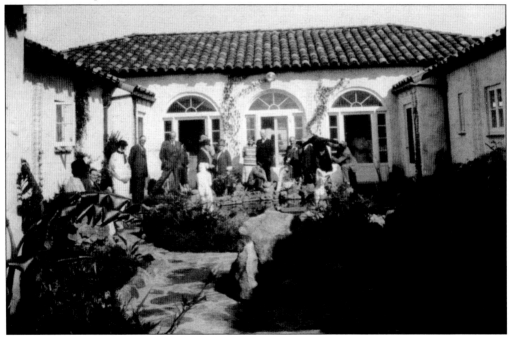

HANSON HOUSE COURTYARD, 1930S. Fred Hansen continued to be the key developer and civic leader of the Mount Helix area. This image was taken in the interior courtyard of this Brittany Spanish Revival–style home. The Fletchers are present, as are other prominent local individuals. Hansen and his showplace home continued to reflect the best of the rural suburban lifestyle that Mount Helix offered.

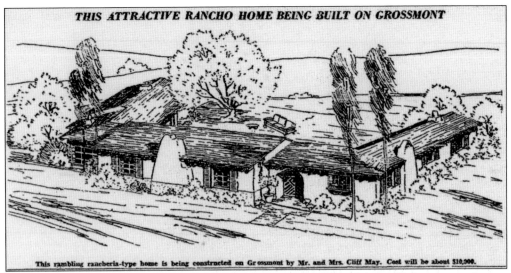

THIS ATTRACTIVE RANCHO HOME BEING BUILT ON GROSSMONT

This rambling rancheria-type home is being constructed on Grossmont by Mr. and Mrs. Cliff May. Cost will be about $10,000.

CLIFF MAY GROSSMONT ADVERTISEMENT, C. 1935. In the 1930s, Mount Helix attracted some of the region's best architects and designers. Even during the Great Depression, Mount Helix and Grossmont residents engaged designers such as Lemon Grove architect Albert Treganza, Rancho Santa Fe's Lillian Rice, and a young San Diego designer Cliff May, who designed two of his pioneering California Rancheria–style homes in the area.

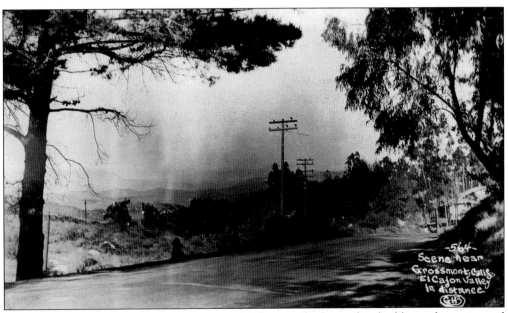

US 80 THROUGH GROSSMONT PASS, C. 1935. The state highway that had been the main road east became part of the US Highway system in 1926. Designated US 80, the state division of highways continued to improve the road, with plans to expand it for high-speed traffic. Still, the highway provided the main access route into Grossmont and beyond to Mount Helix. (El Cajon Historical Society.)

CLAUDE AND VIOLA DAVIS'S CHILDREN, C. 1935, AND DAVIS PROPERTY, C. 1930. Whereas Grossmont initially sought out artists, in the 1920s and 1930s, those who purchased lots and built homes came from broader backgrounds. Claude Davis and his family were a unique example. A Midwesterner who had made money in the insurance business, Claude moved his young family to San Diego in 1924. He purchased eight acres along Grosalia Drive on the north slope of the hill overlooking Grossmont Pass. Davis built a small structure to house his family initially, as seen below. In clearing his acreage to begin an avocado orchard, he recognized that the property's rocky outcroppings provided an opportunity for realizing a storybook suburban home.

YOUNG LADIES AT GROSSMONT QUARRY, c. 1930. Just below his property were the remains of the granite quarries that Ed Fletcher had provided for architect Theodore Kistners's Grossmont High School. Davis spoke with a local Scottish mason who taught him how to split and carve blocks from the native stone that underlay his property.

DAVIS'S FIRST STONE HOUSE, c. 1932. After building a single small building on one of his Grosalia lots, Davis obtained a contract to build a stone-block home for a neighbor. When the neighbor no longer wanted the house, Davis moved his family into the all-stone building at the corner of Sierra Vista and Grosalia Streets in 1930.

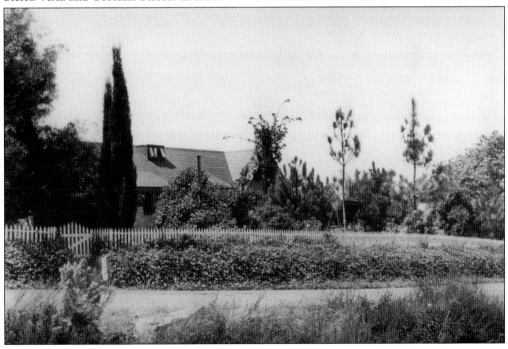

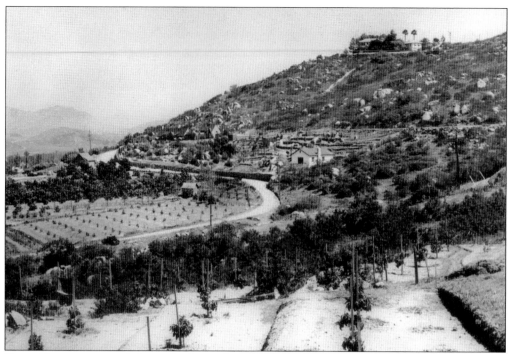

DAVIS RANCH, C. 1935. Davis built another storybook-style stone house next to the original structure on Grosalia, which was then converted into a garage. His family moved into it in 1935. His eldest son, Richard, followed suit after World War II, converting avocado orchards into a third stone house. Davis's first home is center middle, the original garage and second house site at center left, and the Schumann-Heink House at upper right.

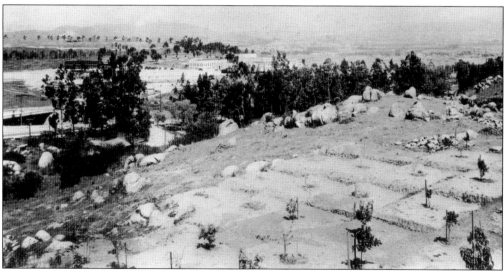

GROSSMONT HIGH FROM DAVIS RANCH, C. 1935. Grossmont High School and its distinctive stone castle building continued to serve as a physical and social landmark. The castle's prominence (center left) on the yet-to-be-developed Fletcher Hills (opened in 1929 but put into financial constraints due to the infamous Mattoon Act's pyramiding tax assessments) is apparent with the still-open and renamed Grossmont Reservoir, seen in the upper left.

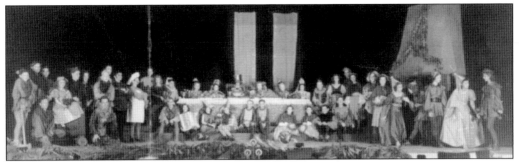

Grossmont High's Christmas Pageant, 1941. The annual Christmas pageant was one of Grossmont High School's earliest traditions and a long-standing institutional community-based event. The first production dated back to 1926, and pageants continued until 1989. Participation in the annual pageant was an honor for drama students and Red Robe Choir members.

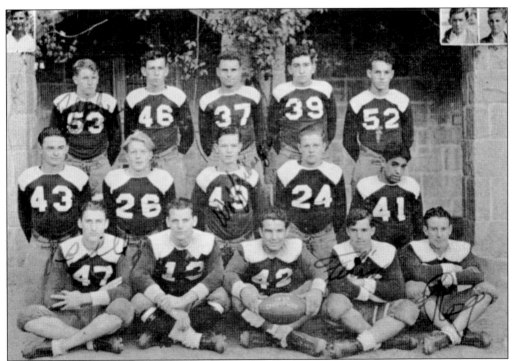

Undefeated Foothillers, c. 1934. Grossmont High served up its pride in its athletic teams as well. That community value was most obvious during the football seasons between 1932–1934 when the Foothillers went 28 straight games without a loss. Coach Jack Mashin's scrappy teams provided East County a point of pride during the depths of the Great Depression.

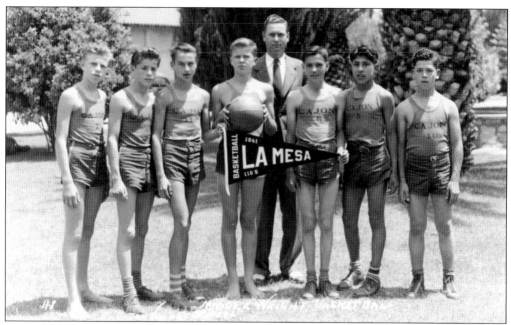

EL CAJON GRAMMAR BASKETBALL CHAMPS, 1941. Many Mount Helix area residents would travel to attend the El Cajon Grammar School on Main Street. The 1930s saw constant expansion of the grammar school using local bonds and Works Progress Administration labor. Here, the 1940–1941 basketball team cherishes its victory in the annual La Mesa Tournament. (Cajon Valley School District.)

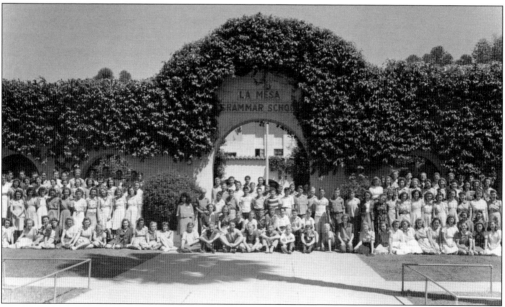

LA MESA GRAMMAR SCHOOL, 1940. The La Mesa Grammar School's growing student body is shown here. The regional school's growth strapped the downtown La Mesa campus. The steadily growing population in the Spring Valley and Casa de Oro area prompted those communities to request their own school. In 1942, with the wartime boom in effect, the Spring Valley Elementary school opened to help address the demand.

View East to Calavo Gardens, c. 1929. This view from Mount Helix illustrates that although the new Calavo Garden subdivisions had been opened, the number of actual homes and ranches constructed during the interwar years are still fairly small. Much of the area continued to be agricultural or still-native chaparral.

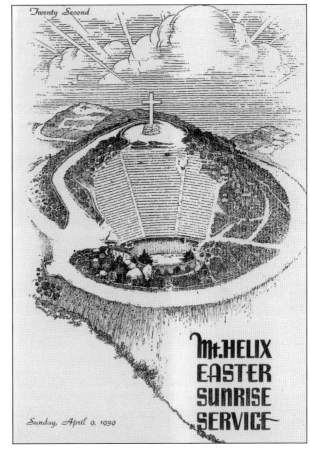

Mount Helix Easter Service Program, 1939. One of the annual institutional events continuing on through the Great Depression was the Easter sunrise service. The Mt. Helix Park, now under the management of San Diego County, also took advantage of the Roosevelt Administration's New Deal programs. Civil Works Administration labor helped improve the road and construct the stone guard walls in place today.

LA MESA SCOUT

Heart of The World's Finest Residential Area

VOL. XXXIV. No. 50. Phone H6-3218 LA MESA, CALIFORNIA, FRIDAY, DECEMBER 12, 1941 YEAR, $2.00. COPY, 5 CENTS

FORM DEFENSE COUNCIL

Blackout Signal In La Mesa Area

In addition to the Army-Navy radio warning of a blackout, La Mesa will signal it with sound.

All police and fire department sirens will be sounded, followed by the ringing of the fire bell, five taps, repeated twice—15 taps of the gong in all. Street lights, of course, will be extinguished, and when the lights go on again it will be the all-clear signal.

All persons are to blacken their places of residence or business at once, after the signal.

Even a lighted cigaret can be seen under favorable conditions for more than 2000 feet, or nearly a half mile, so that importance of a 100 per cent complete blackout can be seen.

Rain Total Is 7.24 Inches

1.51 Since December, According to Federal Gauge in La Mesa

When J. Pluvius' dive bombers go Wednesday afternoon, to

Council Supports Defense

City Appropriates $2500 for Street, Fire Equipment

A La Mesa blackout ordinance, patterned after that of the City of San Diego, was adopted as an emergency measure at a special session of the City Council last evening. The police are empowered to enforce it, and Chief D. G. Smith adds this warning to the public:

"It will be enforced."

La Mesa city council, in session Tuesday evening, adopted a resolution authorizing formation of a La Mesa Civilian Defense commission and naming its heads, and voted a special $2500 appropriation to purchase reserve supplies and equipment for the street and fire departments, for use in case of a major disaster emergency. Increase of the volunteer fire department personnel to 16, and employment of one more regular

Chamber Session To Be Cancelled

The La Mesa Chamber of Commerce meeting, called for tonight, will be cancelled.

It was with regret that Carl Cowen, vice president of the chamber, made this announcement yesterday, since the speaker was to have been George W. Marston of San Diego.

Due to the blackouts, it was feared that the attendance might be too small to warrant having Mr. Marston here.

The San Diego County Development Federation also has cancelled its meeting scheduled for next Tuesday evening, "due to the uncertainty of highway travel during possible blackouts."

It is hoped that as soon as meeting places are properly equipped to guard against light leakage, and autos are equipped for safe night operation during blackouts, that evening affairs again will be conducted practically normally.

Rotarians Look At College Men

See '41 Model Through

La Mesa Disaster Set-up Is Ready for Cooperation In County-wide Group

Volunteer Workers Urged To Register For Service in Case of Need. So Their Abilities May Be Used to Advantage

Turn In Red Cross Work Now

Mrs. Roy Boddy, chairman of the local Red Cross work shop, requests that all outstanding garments be turned in next Wednesday or Thursday, December 17 or 18, so that she can compile her report for the year. Mrs. Boddy announces that the following number of articles have been completed and turned in to headquarters: 60½ dozen pieces of men's women's and children's articles of wearing apparel; 3 complete baby layettes, 3 comforters

La Mesa this week organized a Civilian Defense Council which already has worked out many of the details of operation in case of a major local disaster, for emergency relief. This move has the backing of the City Council, which has appropriated funds for its support and named most of its key members. They are the same men as named by the county's civilian Defense council to take charge of its functioning in this area, so that when the county's machinery gets into full operation, the local situation will key into the wider set-up for prompt and complete coordination.

Vice-Mayor Oliver Schultz is one of the county coordinators, and general chairman in La Mesa, with Councilman Roy Morgan as chief of staff for Schultz. The list

Pan American Program Tues.

Tuesday from 7 to 9 p.m. the Grossmont Evening High Adult Student Pan-American League will hold an installation service with Miss Harriett Babcock, president, in charge.

Dr. Mary Mendenhall of San Diego State college, as guest speak-

PEARL HARBOR HEADLINE, 1941. The announcement of the attack on Pearl Harbor signaled the United States' official entry into World War II. The Navy's expansion of facilities and the growth of the airplane industry quickly doubled the county's population by 1943. Mount Helix reportedly was used for a civil-defense lookout site during the early months of the war.

GROSSMONT HIGH JAPANESE AMERICAN DANCERS, 1934. Although the community would unite, some local citizens would not fare well. During the 1930s, the small but successful group of local Japanese farmers had been integrated into the community. Here, some of their daughters perform a traditional dance at Grossmont High. In April 1942, these well-respected local citizens would all be sent to internment camps for the duration of the war.

Five

MID-CENTURY
RURAL SUBURBIA
1945–1980

World War II had a transformative effect on San Diego County. The county's wartime population had rapidly doubled. Thousands of young men had come through the region as new recruits or to work in the burgeoning war industries. Many of those from colder climates permanently sought out San Diego's version of the American Dream. Subsequently, the area around Mount Helix provided a unique opportunity for realizing it. Those dreaming of raising a baby-booming nuclear family in the California suburbs, the indoor-outdoor lifestyle represented by a new ranch house, were also inspired with the forward-thinking, futuristic Mid-Century Modern lifestyle. Tapping into that intersection of organic architecture and Arts and Crafts aesthetic design made logical sense amongst the granite-filled view lots of Helix and environs. Individual lots and a generally younger professional generation found the semirural landscape perfect for this version of suburban bliss. Visionary architects such as Lloyd Ruocco, Richard Wheeler, Homer Delawie, and others of San Diego's Modernist community found palettes and willing clients here. The larger remote lots in the mostly unincorporated areas limited the typical postwar "garage left, garage right" tract developments and helped create an eclectic modern landscape. Soon, the Grossmont-Mt. Helix Improvement Association (established in 1938) was expanding to address community concerns on zoning and infrastructure for the mostly unincorporated region. Offers of incorporation from both La Mesa and El Cajon were regular discussions, but the challenges of paying for municipal infrastructure would lead to resistance. Yet accommodating the region's exponential growth required expansion of the existing Helix Irrigation District, the creation of the new Otay Water District, fire protection, and financing for multiple new schools for La Mesa-Spring Valley, Cajon Valley, and Grossmont Union High School Districts. New freeways such as US 80 and State Routes 125 and 94 became catalysts for the suburban growth of the area, triggering creation of a regional suburban mall and hospital in Grossmont's name and plans for an entire new city on the old Jamacha ranch.

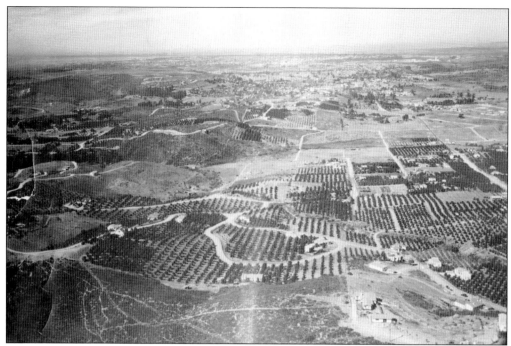

RURAL COMMUNITY, C. 1950. At the end of World War II, the rural nature of the area around Mount Helix is illustrated in this image with the foothills to the west. Growing La Mesa can be seen in the background. In the foreground, the avocado ranchettes still dominate the landscape.

FLETCHER HILLS, C. 1948. The Fletcher Company's Fletcher Hills development, opened in 1929 but nearly lost during the Great Depression, was revived to help meet the growing postwar housing demand. Site of a Civilian Conservation Corps (CCC) soil-conservation camp from 1939 to 1941, Camp La Mesa housed a small arms range and naval medical rehabilitation center during the war. (El Cajon Historical Society.)

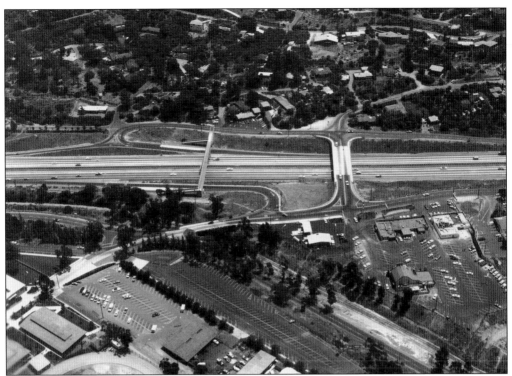

NEW INTERSTATE 8 IN 1969 AND US 80 AND BANCROFT FREEWAY INTERCHANGE IN 1958.
Twenty years later, the California Department of Transportation (later CalTrans) had converted US 80 through Grossmont Pass to the modern mid-century transportation conduit: the interstate freeway. Interstate 8, as with all the freeway expansions in the Helix area, would help open the area to suburban sprawl so prevalent during the postwar period. CalTrans' opening of the modern freeway through La Mesa and El Cajon started in the 1950s when it first developed the route bypassing the old downtowns. The photograph below shows cars waiting to get onto the newly opened Bancroft Freeway (now State Route 125) to travel south to Spring Valley and Lemon Grove. (Both, El Cajon Historical Society.)

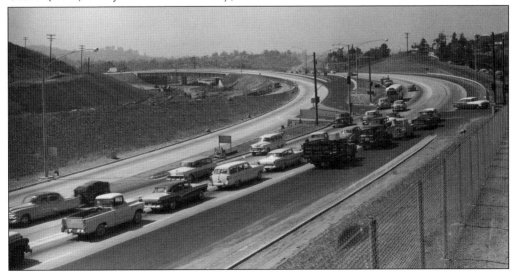

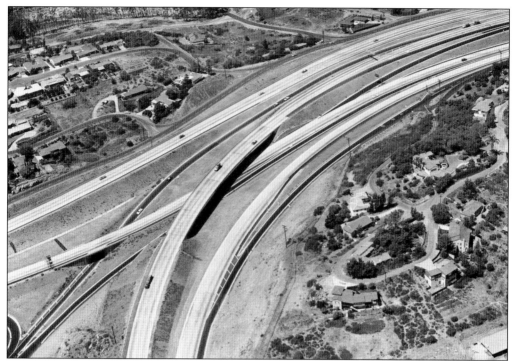

AERIAL OF US 80 AND BANCROFT INTERCHANGE, 1959. This aerial shows the recently completed interchange from US 80 and the Bancroft Freeway (old State Route 67, now State Route 125). The new freeway connected the then end of State Route 94 to the Helix and Grossmont area, forming the area's unofficial western boundary. The west end of Grossmont Colony can be seen at right.

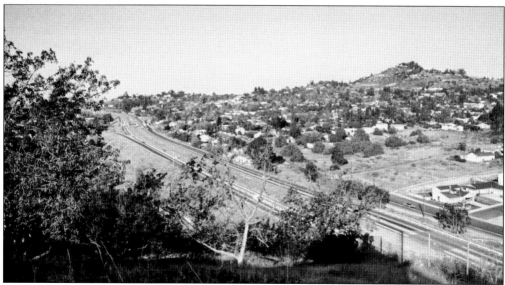

BANCROFT FREEWAY AND GROSSMONT PEAK, C. 1962. The City of La Mesa recognized the importance of this new freeway for civic leaders' expansion and annexation hopes. The Bancroft Freeway opened to much fanfare in 1957 (including a chamber of commerce–sponsored event featuring La Mesa's city council, Miss La Mesa, and county and state officials).

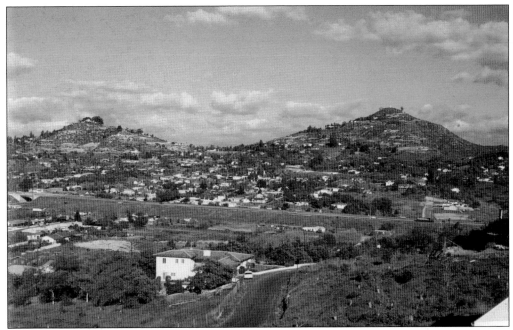

GROSSMONT-HELIX, 1962. Compared with page 68, the two peaks had seen significant development since 1929. Although the City of La Mesa had annexed the westernmost lots beyond the Bancroft Freeway, the majority of Grossmont and the upper slopes of Mount Helix would remain unincorporated, stymied by prohibitive municipal sewer system–connection costs.

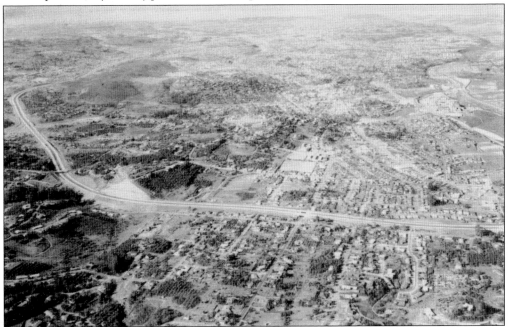

AERIAL VIEW WEST FROM MOUNT HELIX, C. 1956. This high elevation aerial shot taken above Mount Helix illustrates the rapidly changing land uses from agricultural to suburban residential. The new freeway cut its way through La Mesa Highlands before paralleling old Bancroft Drive. Eucalyptus Park is seen at center left.

BUILDING THE DREAM, C. 1953. Many individuals and families who purchased lots and built homes did so without architects or modern designs. In this case, the Adams family purchased this lot on Mariposa Drive and constructed their family home. The image to the left shows the recently cleared lot prepared for the soon-to-be erected minimal traditional house of Contemporary style. The photograph below features the Adams boys enjoying the rural suburban dream in the latest in postwar suburban amenities—the backyard swimming pool. Such prewar amenities would have been considered for only the most affluent Americans, but as the 1950s proved, the dream was now attainable for a far greater number.

POSTWAR SUBURBAN BLISS, C. 1960. The San Diego version of the California Dream aligned with the growth of the working-class nuclear family. This promotional photograph, meant to help recruit teachers and staff to the rapidly growing La Mesa-Spring Valley School District, shows the stereotypical family with their two children and dog pulling a picnic cooler out of the new station wagon in front of their new ranch house. In practice, the newly expanding area around Mount Helix reflected the reality of this lifestyle. New homes, new schools, new shopping centers, new freeways, new cars, and new families were the norm. As shown in the photograph to the right, it also maximized the role of the stay-at-home mom, seen here preparing an outdoor lunch for her little ones in sunny Mount Helix.

OUTDOOR LIVING, HELIX-STYLE, 1959.
From simple patio furniture to a fully landscaped backyard with built-in swimming pool and tropical vegetation, the Mount Helix community embraced the promise of the outdoor lifestyle. This promotional shot for a local real estate developer sells both the casual poolside lifestyle and the perceived glamour of daily life in a bathing suit—while wearing heels, of course.

BABY-BOOM SUBURBS, C. 1959. Riding the pride of America's role in the Allied Victory, the postwar generation moved on with their lives, and key to that were children. The great baby boom that resulted quickly reshaped society, lowering the country's—and especially San Diego County's—average age. Soon, the suburban landscape was full of not only storybook-style ranch houses, but also large numbers of these inquisitive little people.

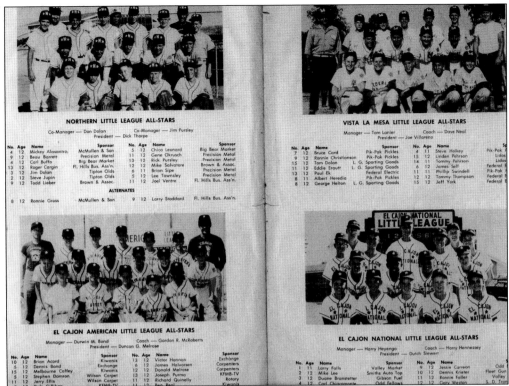

NORTHERN LITTLE LEAGUE ALL-STARS

Co-Manager — Don Dolan Co-Manager — Jim Pursley
President — Dick Thorpe

No.	Age	Name	Sponsor	No.	Age	Name	Sponsor
4	12	Mickey Alasantro	McMullen & Son	5	12	Chico Leonard	Big Bear Market
9	12	Beau Barrett	Precision Metal	11	12	Gene Okrusch	Precision Metal
4	12	Carl Buffa	Big Bear Market	13	12	Rick Pursley	Precision Metal
13	12	Roger Cargin	Fl. Hills Bus. Ass'n.	12	12	Mike Salvatore	Brown & Assoc.
3	12	Jim Dolan	Tipton Olds	6	11	Brian Sipe	Precision Metal
2	12	Steve Jupin	Tipton Olds	5	12	Lee Townsley	Precision Metal
9	12	Todd Lieber	Brown & Assoc.	11	12	Joel Ventre	Fl. Hills Bus. Ass'n.

ALTERNATES

No.	Age	Name	Sponsor	No.	Age	Name	Sponsor
8	12	Ronnie Gross	McMullen & Son	9	12	Larry Stoddard	Fl. Hills Bus. Ass'n.

VISTA LA MESA LITTLE LEAGUE ALL-STARS

Manager — Tom Lanier Coach — Dave Neal
President — Joe Villareno

No.	Age	Name	Sponsor	No.	Age	Name	Sp
7	12	Bruce Card	Pik-Pak Pickles	4	11	Steve Holkey	Pik-Pak
9	12	Ronnie Christianson	Pik-Pak Pickles	15	12	Linden Pehrson	Lidos
15	12	Tom Dolan	L. G. Sporting Goods	14	11	Tommy Pehrson	Lidos
11	12	Eddie Erautt	L. G. Sporting Goods	6	12	James Self	Federal E
13	12	Paul Ek	Federal Electric	11	11	Phillip Swindell	Pik-Pak
8	11	Albert Heredia	Pik-Pak Pickles	12	12	Tommy Thompson	Federal E
8	12	George Helton	L. G. Sporting Goods	15	12	Jeff York	Federal E

EL CAJON AMERICAN LITTLE LEAGUE ALL-STARS

Manager — Durwin M. Bond Coach — Gordon R. McRoberts
President — Duncan G. Melrose

No.	Age	Name	Sponsor	No.	Age	Name	Sponsor
10	12	Brian Acord	Kiwanis	13	12	Victor Hannan	Exchange
5	12	Dennis Bond	Exchange	6	12	James Halvorsen	Carpenters
15	12	Melbourne Coffey	Kiwanis	12	12	Donald Melrose	Carpenters
5	12	Stephen Damron	Wilson Carpet	13	12	Joseph Purma	KFMB-TV
11	12	Jerry Ellis	Wilson Carpet	13	12	Richard Quinelly	Rotary
12	12	Dale Gilliham	KFMB-TV	11	12	Ben Reed	Odd Fellows

EL CAJON NATIONAL LITTLE LEAGUE ALL-STARS

Manager — Harry Heyenga Coach — Harry Hennessey
President — Dutch Siewert

No.	Age	Name	Sponsor	No.	Age	Name	Sponsor
1	11	Larry Falls	Valley Market	9	12	Jessie Cameron	Odd
2	12	Mike Lee	Smiths Auto Top	10	12	Dennis Krieter	Fleet Gun
3	12	Duane Branstetter	Gibson Fuel	11	12	Ronnie Faller	Valley
4	12	Carl Chiaramonte	Odd Fellows	12	12	Gary Weston	S. D. Trans

YOUTH BASEBALL CAPITAL OF AMERICA, C. 1957–1961. Finding productive activities for these youngsters became an institutional need. Youth baseball became a source of success and pride for postwar La Mesa and El Cajon. Soon, thousands of young boys participated, requiring the formation of many new leagues, including the Cajon del Oro league that has played at their Russell Road field since the 1960s. After La Mesa had its Little League, Pony League, and Colt Leagues make their respective 1957 World Series (with the Colt Leaguers winning the championship), the *Sporting News* named La Mesa "Kid League Baseball Capital of America." The success continued when Fletcher Hills' Northern Little Leaguers won the title in 1961. In the shot below, the team participates in the post-victory parades held in both El Cajon and La Mesa.

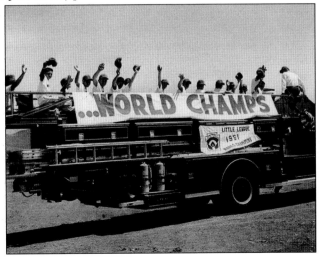

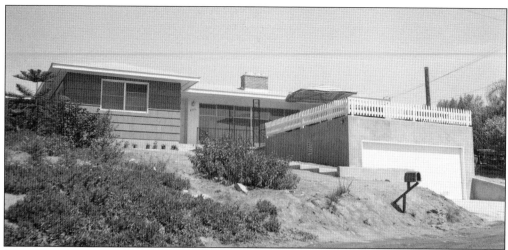

"OUR BLUE HEAVEN," ADAMS HOUSE, 1954. As noted previously, many of the new houses were typical Contemporary-style ranch houses. Here, the Adams House on Mariposa Drive reflects the popular styles that many found more than adequate to raise a family. The region did see some typical suburban tracts developed, such as Bollenbacher and Kelton's Spring Valley Estates, although most home builders constructed individually.

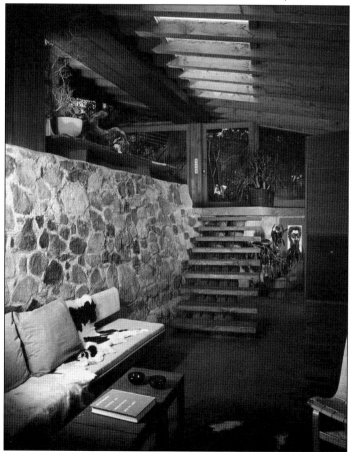

RUOCCO'S "IL CAVO," 1945. Mount Helix's postwar architectural heritage is most directly identified as a palette for local Modern architects such as Lloyd Ruocco. Ruocco was the region's leading Modernist architect when he and new wife, San Diego State College interior design professor Ilse Hamann Ruocco, built this now demolished organic-influenced Modern masterpiece as their first residence near Grossmont Pass in 1945. (Huntington Library.)

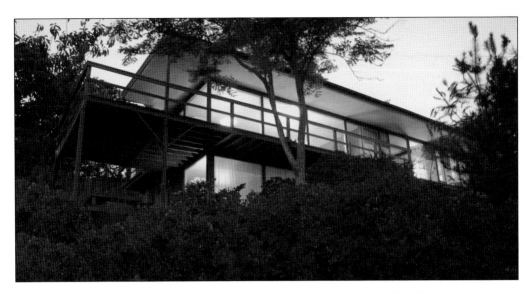

BRINGING MODERNISM TO MOUNT HELIX, LILLIE RESIDENCE, 1958. Lloyd Ruocco's interest showed itself at San Diego High School in the 1920s. The University of California, Berkeley graduate gained experience working in Richard Requa and William Templeton Johnson's offices and then as an independent architect and planner. He quickly became recognized, as architect Robert Mosher recalled, as the San Diego Modernist one "turned to for inspiration." Lloyd and Ilse Ruocco opened the influential Design Center in San Diego in 1949. Over the ensuing decades, Lloyd built and sold numerous custom Mid-Century Modern houses in the Grossmont, Mount Helix, and La Mesa areas. This one, the 1958 T.W. Lillie house, reflected Ruocco's goals for smaller homes that addressed the owner's everyday needs. The house is now a County Historical Landmark. (Both, Pitman collection.)

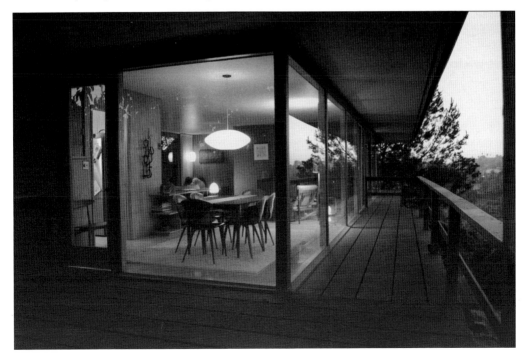

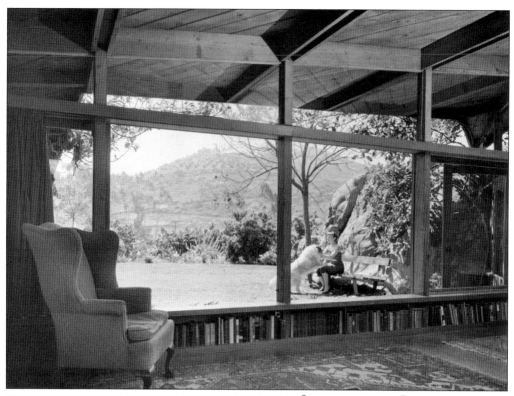

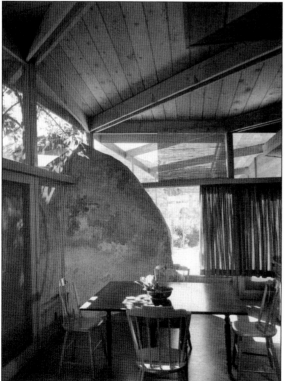

INTEGRATING THE INDIGENOUS, HOLMGREN HOUSE, 1948. As Ruocco historian Todd Pitman has documented, Ruocco's houses reflect his interest in integrating the region's natural landscape into his designs. He built many of his houses with redwood and glass walls to maximize their relationship to the site's natural character. He used local stone, a character-defining element of the Grossmont-Helix area, including the incorporation of existing boulders and other landscape features exhibited here in the 1948 Holmgren House on Grossmont. Other similar and notable Ruocco houses constructed in the region include the Barwick Residence (Spring Valley, 1955), Cole Residence (Briar Tract, 1952), Grossmont Spec House (Briar Tract, 1969, demolished), Jackson Residence (Mayapan Drive, 1949), Jones/Bleecker Residence (Grossmont, 1949) and the Wexler Residence (Grossmont, 1960). (Both, Pitman collection.)

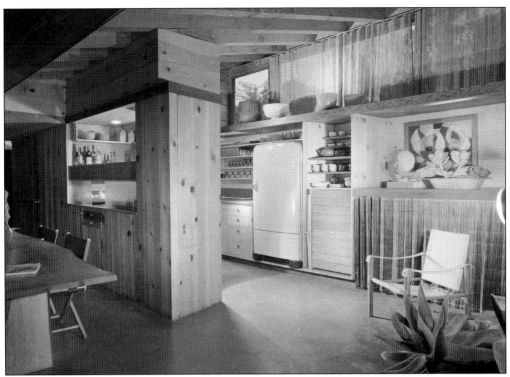

BRINGING THE INDOORS OUT AND THE OUTDOORS IN, C. 1960. These images reflect the indoor and outdoor expressions of the Modernist philosophy that fueled the numerous examples constructed around Mount Helix. Lloyd Ruocco notably illustrated the basic approach in his oft-quoted statement, "Good architecture should call for the minimum use of materials for the most interesting and functional enclosure of space." San Diego's Modernist contemporaries followed his lead. For those practicing in the Grossmont-Mount Helix area, most took care in their building sites to take advantage of the expansive views. They would also use re-sawn or rough-sawn lumber to enhance the natural character and take advantage of post-and-beam construction to minimize load-bearing walls and create open interior spaces. Glass-walled elevations ensured a direct indoor-outdoor integration of space. (Both, Pitman collection.)

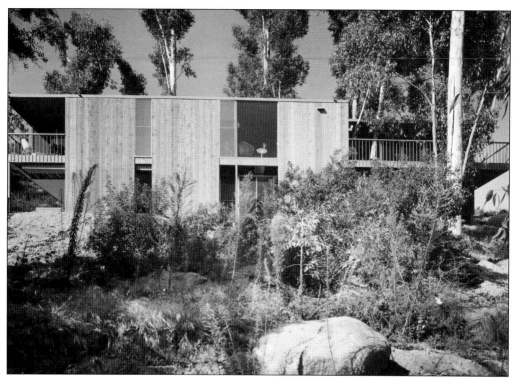

MODERN LEGACY, CASADY RESIDENCE, 1961. Many other architects found the Mount Helix area, and its Modern-thinking clients, a productive palette. Here, the front facade and rear entrance of San Diego architect Homer Delawie's 1961 Casady Residence near Grossmont provides an exemplary example of the Mid-Century Modern. Many other notable San Diego Modernist architects and designers are documented contributors to the area's architectural landscape. Other locals completing residential work include Ron Davis, Arthur Decker, Robert Des Laurier, John Dirks, Russell Forester, Henry Hester, A. Quincy Jones, Kendrick Bangs Kellogg, Richard Lareau, John Mock, John Mortenson, C.J. Paderewski, Sim Bruce Richards, and Richard Wheeler, to name the most prominent. Some of these designers, as well as other Modernist architects, would also find work in building area schools, churches, and commercial buildings. (Both, Pitman collection.)

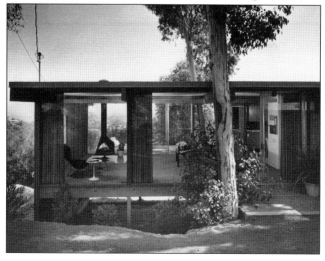

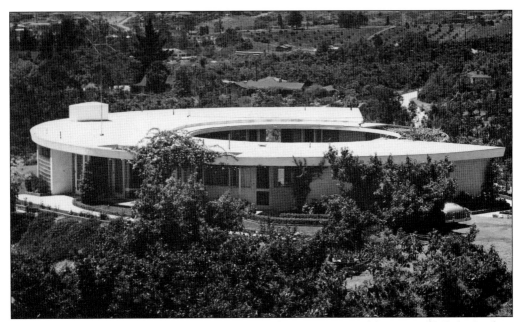

JACOBSON HOUSE, 1948. Lloyd Ruocco designed a unique round home in 1948 for Isadore Jacobson, a San Diego businessman and civic leader in the regional Jewish community. In this case, the building, located on the foothills west of Mount Helix, featured all rooms opening into a central brick-lined patio, supported with a unique steel post and beam support structure. (Pitman collection.)

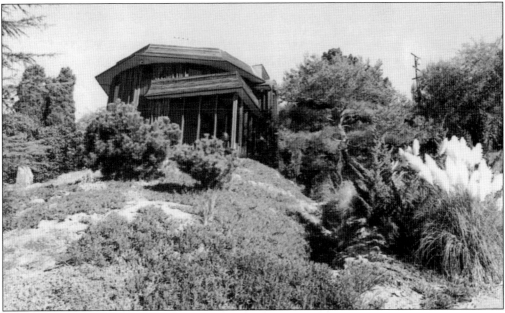

MIC MEAD HOUSE, 1973. Trained forester and craftsman Mic Mead was one of many local designers and builders constructing unique and impressive area residences. Mead purchased this lot on Mount Helix for its nearly 300-degree view. Working with a draftsman and engineer, he personally integrated tropical wood into the walls, floors, and details of this contemporary showplace. (Mic Mead.)

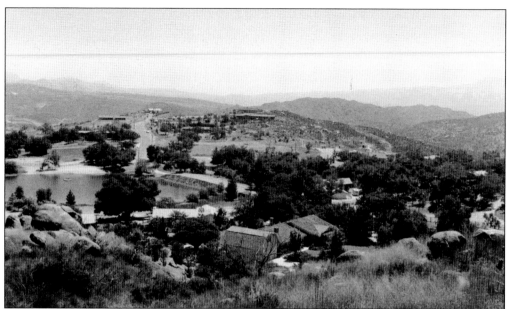

HELIX LAKE, 1967, AND HELIX LAKE ESTATES, 1975. The La Mesa, Lemon Grove, and Spring Valley Irrigation District constructed this storage reservoir in 1927. Initially used to supply the Lemon Grove and Spring Valley area, it fell into disrepair in the late 1950s when the updated system no longer required this facility. Golden Construction Company purchased the property in the 1960s from the renamed Helix Irrigation District. The company planned an exclusive residential project with lake frontage lots. Helix Lake Estates eventually opened with 26 high-end homes. The City of La Mesa annexed land along Lemon Avenue to extend out to and incorporate the lake and its residences.

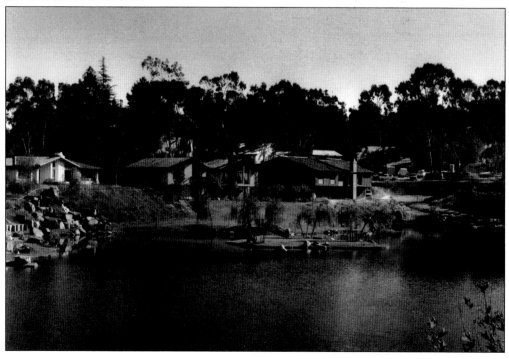

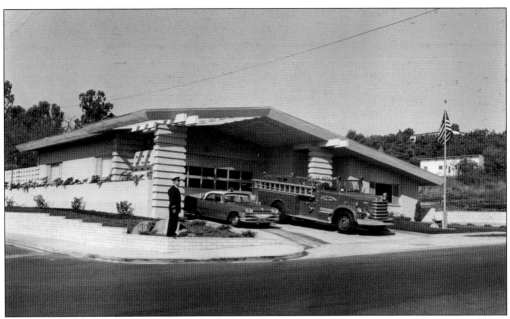

GROSSMONT FIRE STATION NO. 13 IN 1962. La Mesa had incorporated much of the western slope of Grossmont and Mount Helix into its city limits. One of its several efforts to try and convince additional neighborhoods to incorporate was its municipal fire department. In 1962, the city opened its third fire station, at the northwest corner of Grossmont and Bancroft, to serve these eastern city residents.

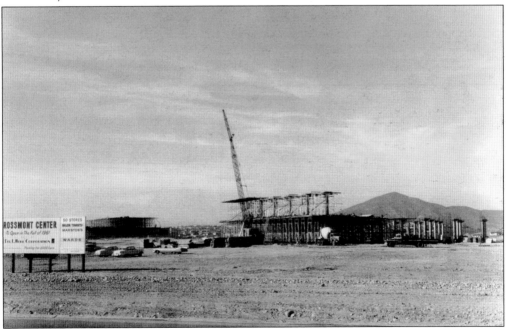

GROSSMONT CENTER CONSTRUCTION, 1959. Postwar suburban growth required the concurrent expansion of retail services. In 1957, San Diego's Marston's Department Store announced plans to anchor a new regional mall in La Mesa on land north of US 80. The developers hired the nationally renowned Del Webb Corporation to oversee construction of the popular local center.

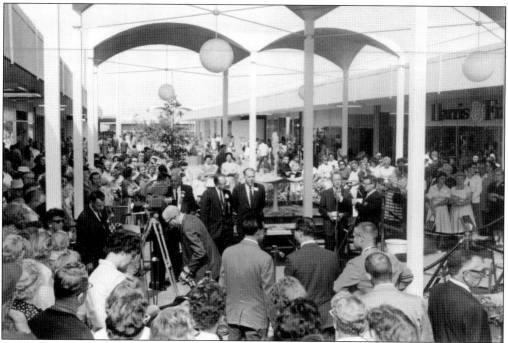

OPENING DAY AT GROSSMONT CENTER, 1961. Los Angeles design and planning firm Welton Beckett and Associates was hired to design the new Modern-style center. Beckett's original design details included the hard-domed shade structures erected for customer comfort in the open-air mall areas and also to provide cover over main building entrances. Grossmont Center was the third regional mall to open in the county after College Grove and Mission Valley Center. Opening day in October 1961 featured a capacity crowd for East County's first such retail center. Brass bands, barbershop quartets, local civic and business leaders, and other celebrities, such as members of the brand new San Diego Chargers professional football franchise, attended along with thousands of local and regional residents. The center has been an economic mainstay for La Mesa ever since.

New Grossmont Hospital, 1955. East County residents overwhelmingly passed a 1951 bond act to match state and federal funds for constructing this first regional hospital for East County. The hospital district hired the nationally known Los Angeles architectural firm of William Perriera and Charles Luckman to design the initial $2-million 100-bed Modern-style facility that opened in 1955.

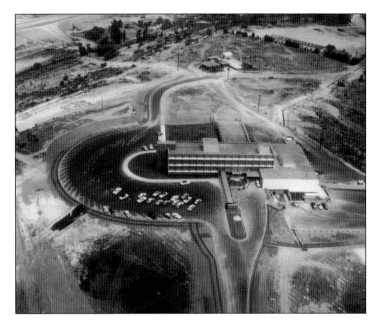

Trinity Lutheran Church, Spring Valley, 1961. Reflective of the changes in land use in the postwar era is the evolution of the former La Mesa Country Club. In 1951, the Brookside Development Company converted the former golf course into houses, and a local church purchased the old clubhouse. In 1961, Pasadena architect Culver Heaton's Modern chapel was completed, still serving as an iconic landmark for Spring Valley today.

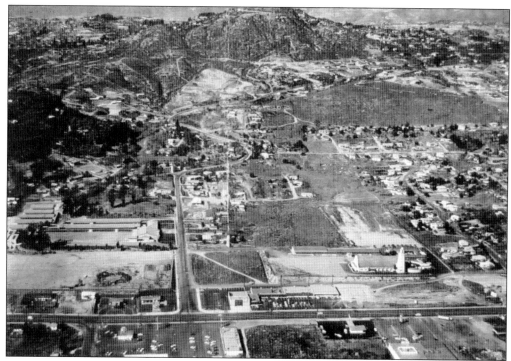

CASA DE ORO AERIAL, 1964, AND SANTA SOPHIA CHURCH, 1959. East on State Highway 94 was the steadily growing Casa de Oro. As this 1964 aerial illustrates, it was not fully built out. Conrad Drive is shown at center with Campo Road (SR 94) in the foreground and the iconic Santa Sophia Catholic Church at the community center. The San Diego Diocese opened this parish in 1956 to serve the Catholic community in the growing Spring Valley and Casa de Oro area. San Diego architect George Lykos designed this Modern ode to the older Mission Revival style. Today, the Santa Sophia tower still serves as arguably the most identifiable Casa de Oro landmark. (Both, Santa Sophia Catholic Church.)

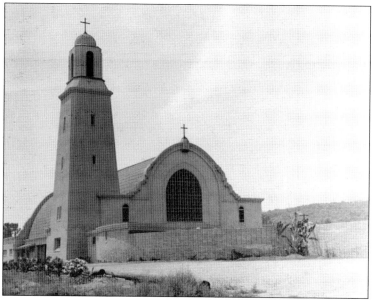

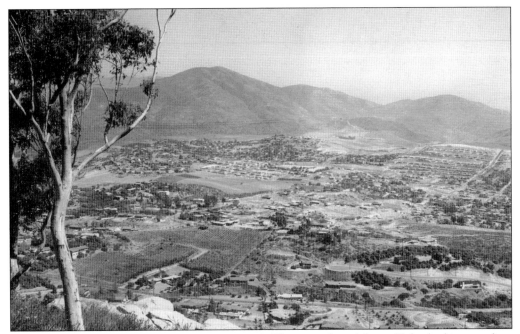

VIEW SOUTH TOWARD MOUNT MIGUEL, C. 1965. This view from Mount Helix looking south at Casa de Oro and the early developments in Sweetwater Springs around Monte Vista High School is a landscape soon to fill in. That change would be energized with the completion of the State Route 94 freeway in 1970, which cut through a corridor in the photograph's center.

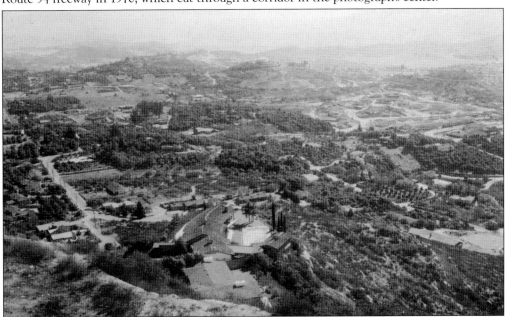

VIEW EAST TOWARD CALAVO GARDENS, C. 1965. This eastern view of Mount Helix shows a similar development story by the mid-1960s. Many new Modern and ranch-style homes with swimming pools and other suburban amenities are slowly replacing the sea of avocado orchards. Now the Calavo Gardens area, and its neighbors east of Avocado Boulevard, including the Sefton-Sharp family's Monte Vista Ranch, would soon be slated for further development.

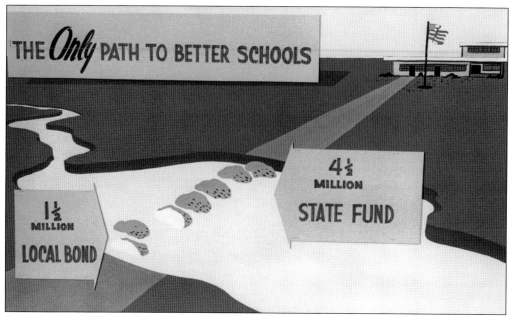

SCHOOLS FOR THE BOOMERS, 1952. All this suburban growth, full of baby-booming nuclear families, required the establishment of that most American of civic institutions: the public school. La Mesa-Spring Valley, Cajon Valley, and the Grossmont Union High School Districts all commissioned studies to address the coming postwar boom, then campaigned and led victorious bond acts to help fund badly needed schools.

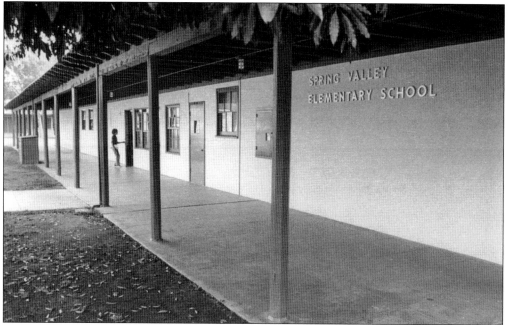

SPRING VALLEY ELEMENTARY, 1960s. Although Spring Valley's residents had been campaigning for their own school since 1929, it would take the World War II boom to obtain this second district school. Designed by Lemon Grove architect Alberto Treganza, Spring Valley Elementary opened in 1942, along with his initial Lemon Avenue School building in La Mesa in 1943.

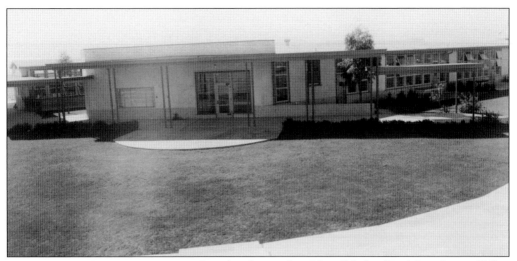

CASA DE ORO ELEMENTARY, 1960s. Local architect Sam Hamill helped La Mesa-Spring Valley School District complete their early 1950s expansion. His contract resulted in designs for numerous schools, including Casa de Oro (1948) and Spring Valley's Bancroft Elementary (1956). Especially in these unincorporated areas, the local public schools quickly became, just as their 19th-century predecessors, the de facto civic centers for these suburban communities.

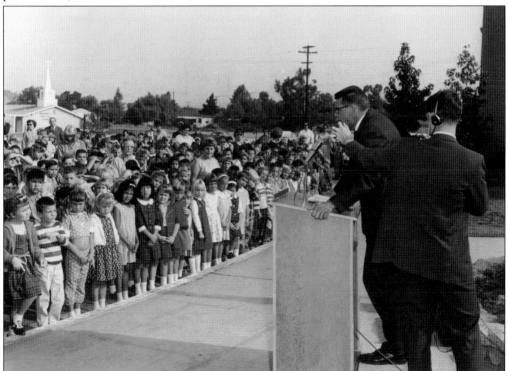

GLENN MURDOCK AT BANCROFT ELEMENTARY, c. 1956. For La Mesa-Spring Valley School District, the ability to complete a program of building and staffing over a dozen new schools within 15 years fell to district superintendent Glenn Murdock. Seen here addressing the student body at Bancroft Elementary, Murdock provided leadership and stability for the district's great expansion program.

RANCHO ELEMENTARY CONSTRUCTION AND AVONDALE PROSPECTS, 1959. For the rapidly growing postwar tract-house neighborhoods in northern La Mesa and southern Spring Valley, the school district struggled to meet the demand. When developers Bollenbacher and Kelton (also developers of Allied Gardens, Emerald Hills, and Murray Manor) rapidly turned undeveloped western Spring Valley into a community of hundreds of tract homes, the district could not get Rancho and Avondale schools built fast enough. These views show the land soon to be filled with homes behind the under-construction Rancho Elementary School and the need to borrow a model home for coordinating registration for the unfinished, but desperately needed, Avondale Elementary School. Both schools opened in 1960 to full classrooms.

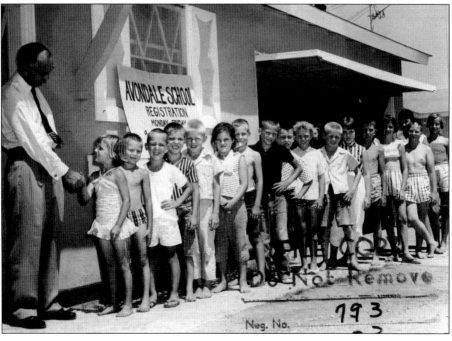

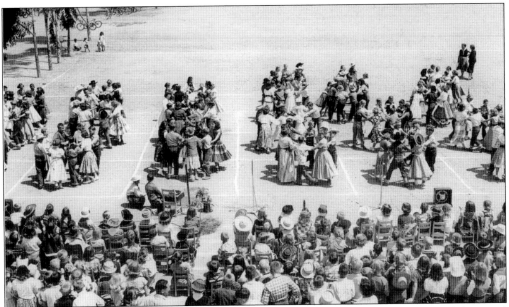

FLETCHER HILLS SQUARE DANCERS, C. 1956. Similar concerns and needs affected the rapid development of the Fletcher Hills area. Responding to the growth of Nels Severin's Severin Manor tract along with the higher-end Grossmont Hills tract required the 1951 openings of the Sam Hamill–designed Fletcher Hills and Northmont (originally Severin) Elementary Schools. Annexation efforts eventually split the neighborhood between La Mesa and El Cajon.

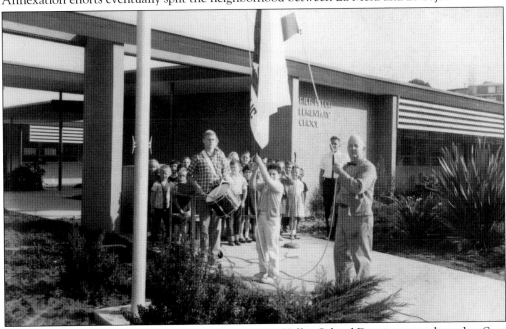

BRIAR PATCH ELEMENTARY, C. 1964. La Mesa-Spring Valley School District opened another Sam Hamill–designed school on the old Briar Tract across the street from the Eucalyptus Reservoir in 1958. Interestingly, the school requested permission from Walt Disney himself to use Disney's Br'er Rabbit character from their then-popular, but now controversial, animated *Song of the South* film as a school mascot. The school closed in the 1980s.

HIGHLANDS ELEMENTARY CONSTRUCTION, 1961. District planners got ahead of the coming development in the eastern Spring Valley/Sweetwater area south of Highway 94. Here, school construction is underway along South Barcelona Street prior to the opening of the Helix Vista and Sweetwater Highlands subdivisions. Recently furrowed tomato fields are in the foreground. Within a few years, these fields and hills were full of houses.

MURDOCK ELEMENTARY MEDIA CENTER, 1972. La Mesa-Spring Valley School District continued to grow with the community. In 1972, the district opened this Conrad Drive campus named for the recently retired superintendent. It provided Mount Helix's first and only local elementary school. As the La Presa and Sweetwater areas continued to grow, the district would add Kempton (1965), Loma (1978) and Sweetwater Springs (1993) Schools.

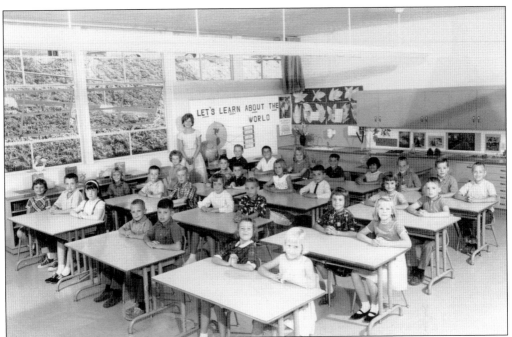

FUERTE ELEMENTARY THIRD GRADERS, 1964, AND HILLSDALE MIDDLE, 1995. Neighboring Cajon Valley School District faced similar challenges with exponential growth. This included some early-1960s boundary trades with La Mesa-Spring Valley School District. The Cajon Valley Union School District similarly approved bonds to pay for construction of numerous new schools. The first of those over the hills to the south was Fuerte, which opened in 1959. Once the boundary deals were complete, Avocado Elementary School opened in 1970 with Rancho San Diego Elementary School following in 1986 and a new Jamacha Elementary School in 1992. Rancho San Diego's growth was such in the early 1990s, the practice of sending middle school students back over the hill was addressed with the 1995 opening of Hillsdale Middle, reintroducing the historical school name. (Both, Cajon Valley School District.)

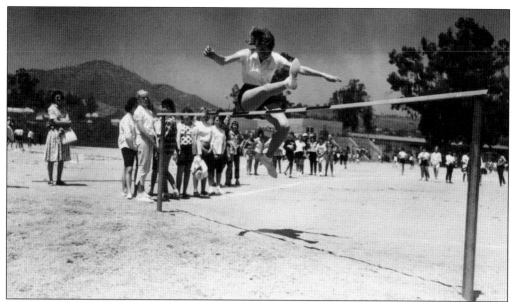

SPRING VALLEY JUNIOR HIGH TRACK MEET, C. 1962, AND LA PRESA JUNIOR HIGH PLAN, 1962.
Middle or intermediate schools were another postwar education innovation. La Mesa-Spring
Valley School District had addressed this new need with the Sam Hamill–designed La Mesa Junior
High (1952) and Spring Valley Junior High (1954) in Casa de Oro. These were followed with
Clyde Hufbauer's Parkway Middle School (1961) on Fletcher Parkway and Robert Des Lauriers's
and partner Sig Sigurdson's La Presa Junior High School (1963) next to Kempton Elementary.
Above, a brave Spring Valley coed attempts the high jump with nothing more than a few inches
of sawdust for a landing pit. The Des Lauriers-Sigurdson's La Presa site plan below.

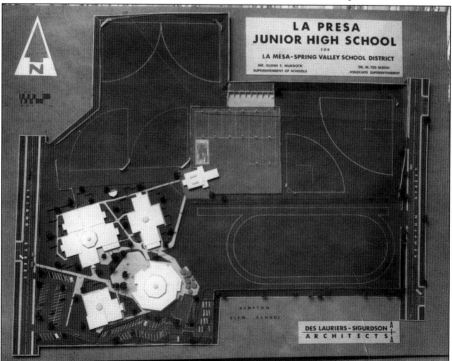

IN FRONT OF GROSSMONT HIGH SCHOOL, C. 1948. Grossmont Union High School District was still a one-campus operation at the end of World War II. Similar to the concerns at the lower school districts, the board would be challenged with an exponentially growing student population. From 1951 to 1974, the district would add seven new high schools, with four directly serving the area around Mount Helix. (El Cajon Historical Society.)

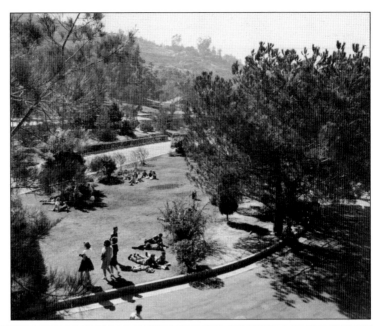

HELIX HIGH SCHOOL, 1952. District expansion plans recognized the growing needs of La Mesa and El Cajon. When Rolando, Lemon Grove, and Spring Valley residents complained of local students attending a La Mesa High School, the board renamed it for the regional landmark. Delays in construction required holding the school's initial year at Grossmont's campus before the Highlanders' 1952 opening. A third campus, the new El Cajon Valley High School, would open in 1955.

MOUNT MIGUEL HIGH SCHOOL CONSTRUCTION, 1957, AND LOCAL RIVALS, 1965. Spring Valley, La Presa, and Lemon Grove's rapid suburban growth made it the next district-expansion priority. The subsequent fourth campus, designed by El Cajon architect Herluf Brydegaard, opened in September 1957. Following the Helix High School precedent and naming the school for nearby Mount San Miguel, the student body rebelled against the district committee chosen "49ers" nickname. In an overwhelming vote, the "Red and Black" chose Matadors. With many students pulled from Helix High, the Matadors' initial rival was the Highlanders. After their similarly named eastern neighbor Monte Vista High opened in 1961, the list of competitive rivals in athletics, band competitions, and suburban pride expanded. (Above, Mount Miguel High School; left, Monte Vista High School.)

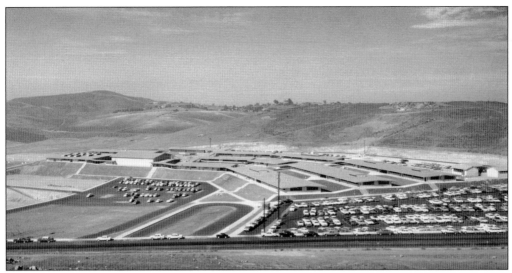

NEW MONTE VISTA HIGH, 1961, AND HELIX VIEW TRACTS, 1967. Grossmont Union District planners recognized the coming suburban growth of the Casa de Oro and Sweetwater Springs region. The shot above was taken at the opening of the Herluf Brydegaard and Robert Ferris designed campus in September 1961. Most of the surrounding area was still agricultural; local farmer Howard Takahashi's produce stand was a community fixture at Jamacha and Sweetwater Springs Boulevards through the 1970s. Within six years of the Monarchs' campus opening, it was being surrounded with the adjacent Helix View subdivisions. Soon, Sweetwater Springs Road would be built up with shopping centers and retail support for the thousands of new residents in the surrounding Sweetwater Village, Loma Rancho, Mt. Helix Homelands, and Helix Acres tracts.

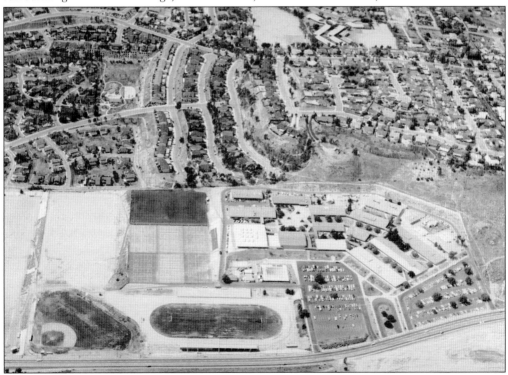

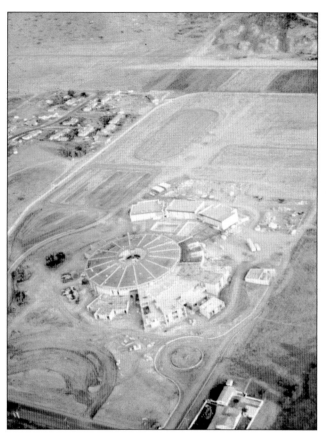

VALHALLA HIGH, AERIAL AND INTERIOR, 1974. As the former rural hills and valleys east of Avocado and Jamacha Boulevards filled with new homes, and major plans were being unveiled for the former Monte Vista Ranch, another high school was needed. Following the popular trend in education during the early 1970s for open flexible space, architect Ron D. Young's distinctive campus design featured a circular three-story main building with perimeter classrooms and central common areas. This futuristic design clearly inspired Norsemen academic and athletic success, including such notable alumni as Olympic diving gold medalist Greg Louganis and motocross champion Broc Glover. The district eventually added Jamul's Steele Canyon High School in 2000 to round out the district's southern campuses. (Both, Valhalla High School.)

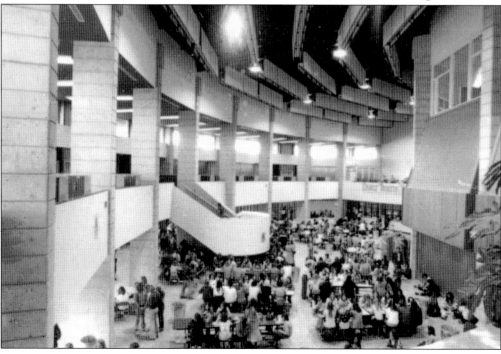

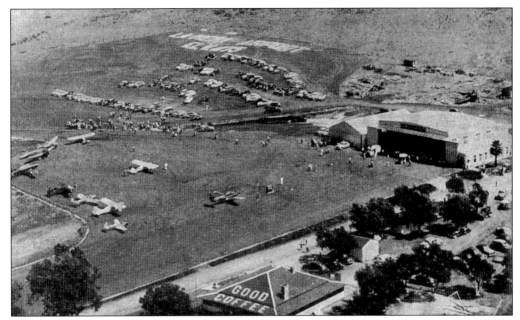

LA MESA AIRPORT AT SWEETWATER SPRINGS, 1951. On September 15, 1951, more than 5,000 spectators visited this newly renamed airfield located at the intersection of Jamacha and Sweetwater Springs Boulevards. As with Mount Helix, owner Fred Hansen had great visions for developing his Sweetwater Highlands lands around old Isham Springs as a resort. However, the incompatible mixture of an airfield and proposed housing predestined its closure by 1955.

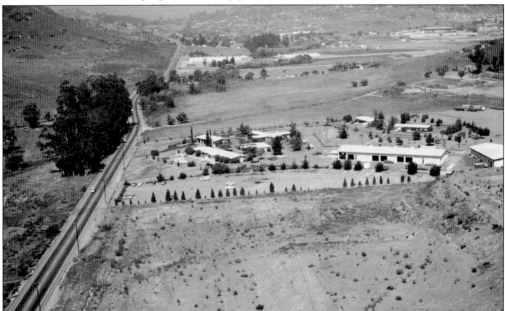

CALIFORNIA DEPARTMENT OF FORESTRY STATION, 1970s. Fire protection for the rural unincorporated region was a regular concern. The California Department of Forestry (CDF) had a station in downtown La Mesa for several decades before moving to this Jamacha Boulevard site in 1967. CDF supported the local Grossmont-Mt. Helix Fire District, established in 1957, as well as the San Miguel and Spring Valley Fire Districts. (CalFire.)

GROSSMONT-MT. HELIX FIRE STATION, C. 1980. Formed to provide fire protection and emergency medical services for the unincorporated areas, the county donated this station site on Vivera Drive to the newly formed district. Opened in 1960, this Mount Helix station served the citizens of the original eight-square-mile district and expanded to include Steele Canyon, Granite Hills, and Hillsdale in the 1970s.

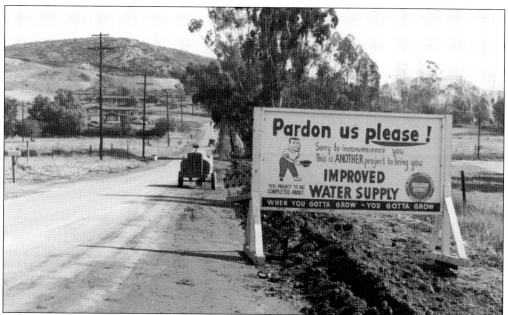

HELIX IRRIGATION DISTRICT EXPANSION, C. 1950. The La Mesa, Lemon Grove, and Spring Valley Irrigation District proved essential for regional growth. Leadership from long-serving staff such as Chet Harrett, Harry Griffin, and Bill Jennings helped guide system modernization and expansion. In 1956, after annexing El Cajon Irrigation, they became the Helix Irrigation District, and in 1973, with mostly urban customers, Helix Water District. (Helix Water District.)

OTAY WATER DISTRICT OFFICES AND BOARD, C. 1959. When Helix Irrigation District refused to annex Sweetwater Springs and La Presa, Fred Hansen (second from right) joined with other property owners and developers to create the Otay Municipal Water District and the Spring Valley Sanitation District. This infrastructure allowed for the rapid suburbanization of Spring Valley and La Presa in the early 1960s. (Otay Water District.)

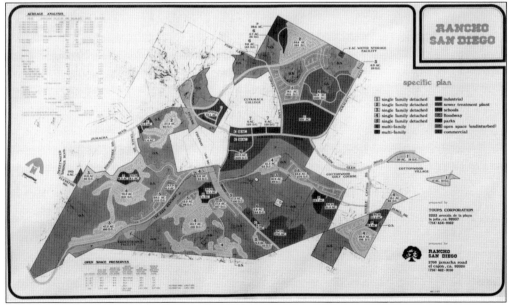

A NEW MASTER-PLANNED TOWN, 1970s. Such infrastructure inspired the Rancho San Diego Corporation's purchase of the undeveloped Monte Vista, Cottonwood, and Sweetwater Ranches in 1970. Counting on planned freeway expansions (State Routes 94 and 54), the corporation envisioned 20,000 residents along with new schools, parks, retail, and open spaces. Implementation was scaled back and took closer to 20 years to build out, but suburbia had reached old Jamacha.

CUYAMACA COLLEGE, GROUND BREAKING, 1977, AND ENTRANCE, 1979. One of the anchors for Rancho San Diego's development was a new community college campus. The second campus of the Grossmont Community College District (Grossmont College actually shared the Monte Vista High School campus in the early 1960s), the 165-acre Cuyamaca College site was acquired in 1972 from the Rancho San Diego Corporation and first opened in 1978. With the delays in Rancho San Diego's development, the campus was one of the first community components to be completed. The district quickly completed a second phase of buildings in 1980 and has continued to expand its facilities and programs to meet the steadily growing demand. (Both, Grossmont College District.)

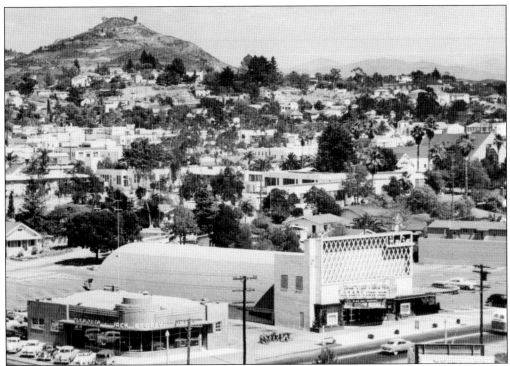

HELIX THEATER, LA MESA, C. 1953, AND MOUNT HELIX PARADE FLOAT, 1951. Although the postwar expansion of the surrounding communities had moved forward on their own paths, the region continually refocused its gaze back at Mount Helix. Its physical and geographic influence was found in its namesake high school and in businesses such as La Mesa's Helix View Café and the popular Helix Theater (above). The peak and cross also was found on the city of La Mesa's official logo for decades (although the mountain was never within the city limits). Mount Helix's cultural influence, such as the Easter sunrise services, long sponsored by the La Mesa Rotary Club, is illustrated with its Fiesta de Las Flores parade float (below).

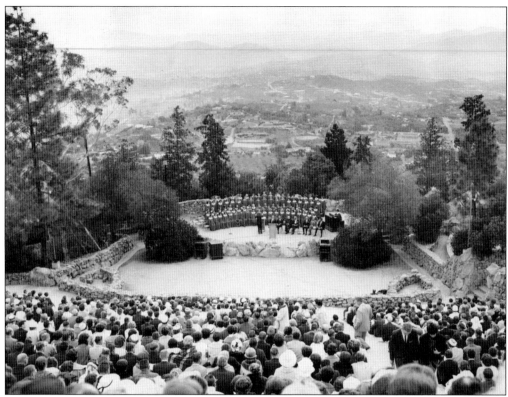

MOUNT HELIX THEATER EVENT, C. 1962, AND AERIAL VIEW, 1960S. The Yawkeys entrusting of the Mt. Helix Park to the county had long been entrenched as a foundational community asset. In addition to the annual Easter services, the community had found additional uses for the iconic facility. Concerts, school graduations, weddings, and other special events, along with its daily use as a public park, proved popular. Its community landmark role was as solid as its granite foundation, yet as the 1980s came to an end, those with philosophical concerns over the park's affiliation with its religious symbolism and uses engaged in a previously unforeseen battle.

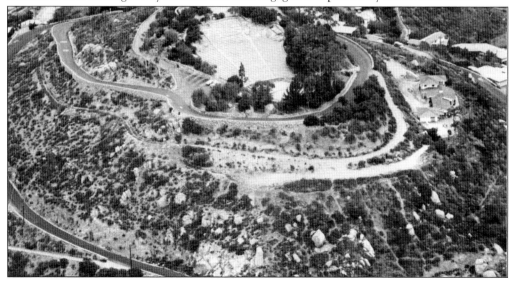

Six

THE BATTLE
AND THE VICTORY
1980–PRESENT

As the Mount Helix community entered the 1980s, the area continued its growth with infill housing in established Grossmont, Mount Helix, Calavo Gardens, and Casa de Oro and, in the larger scale, newer developments to the south in Sweetwater Springs and Rancho San Diego. Although Rancho San Diego would not see the originally conceived freeways to feed a new municipality, as the new millennium arrived, planned retail and commercial improvements along with higher-density housing soon surrounded the foundation that Cuyamaca College established. To the outsider, the Mount Helix area appeared a stable and content community. Yet a challenge to the community's iconic core landmark, the Mount Helix cross, had arisen. Some local citizens backed by the American Civil Liberties Union (ACLU) had challenged both San Diego County and the City of La Mesa on these agencies' physical, symbolic, and fiscal support of the nature theater's cross on public land—and the city's official logo. As the 1990s arrived, subsequent lawsuits were filed. The challengers asserted that the support of these religious symbols on public land and property was unconstitutional. Initial US District Court rulings supported the challengers. The City of La Mesa removed the cross from their logos as directed, but the county attempted to transfer the park's cross property to the private nonprofit San Diego Historical Society. In the meantime, community leaders, including an unlikely and undaunted young man, worked to justify the property's historical value to its community. When the transfer to the historical society was deemed inappropriate, many lost hope for an amicable resolution that a vast majority in the community desired. In 1999, with the battle seemingly lost, a farsighted group moved forward to incorporate a new nonprofit corporation, the Mt. Helix Park Foundation, to take on the ownership and operations of the park. Creating a unique privately owned and operated public park has resulted in not only settlement of the legal challenges, but also in the long-term preservation of this historic public asset—a community victory for all involved. Most images in this chapter are courtesy of the Mt. Helix Park Foundation.

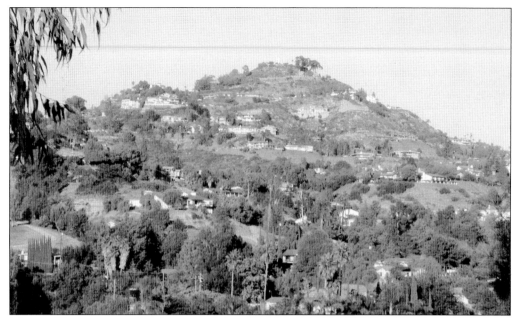

MOUNT HELIX, 1990S. By the 1990s, Mount Helix was not only regionally renowned for its magnificent mountaintop park and theater, but also as a model rural suburban community. Still mostly unincorporated territory, its natural and cultural charms held longtime residents while attracting young families eager to live a piece of the Mount Helix version of the American Dream lifestyle.

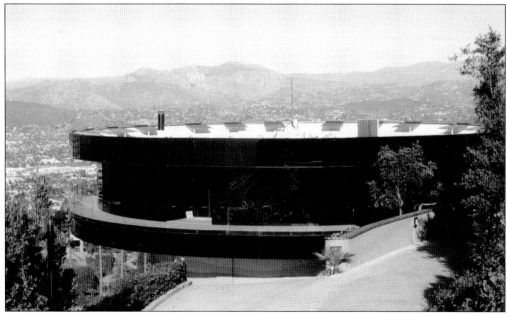

JOHNSTONE ROTATING HOUSE, 2004. Mount Helix's passion for unique architecture continues, but nothing quite compares to this piece of kinetic architecture on the north slope of Mount Helix. Conceived, designed, and constructed by Al and Janet Johnstone, this 3,700-square-foot house has a fully rotating second floor that can provide, unlike any other home, a true 360-degree view. (rotatinghome.com.)

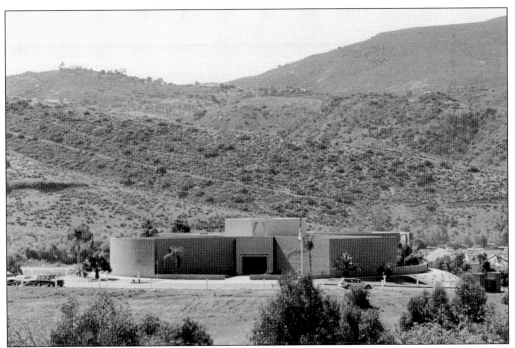

HERITAGE OF THE AMERICAS MUSEUM, 1992. Cuyamaca College expanded its role as a community asset with the 1992 opening of this museum dedicated to the study of natural history, archaeology, anthropology, and the art of the Americas. In 1999, the college also opened a popular water-conservation garden to show the greater community how they can personally protect this invaluable resource. (Grossmont College District.)

SUNRISE SERVICE PROGRAM, 1998. The La Mesa Rotary Club continued their decades-long association with the Mount Helix sunrise services through the 1990s. Formed in 1925, it is the third oldest service club in La Mesa. The cover of the 1998 event program clearly identifies the topic that was on the minds of all who had experienced and supported this then-threatened event.

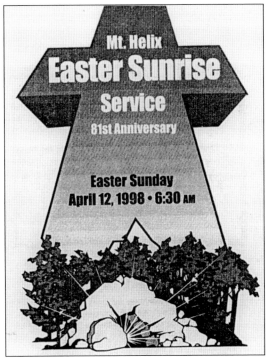

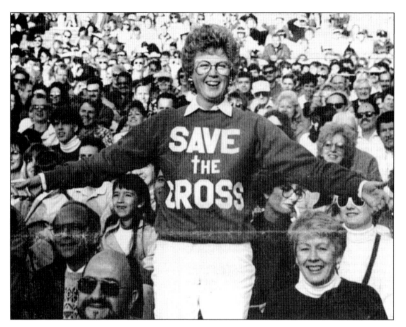

BATTLE TO SAVE THE CROSS, 1992. With the legal challenges against Mount Helix in the public eye, the local community rallied to support and protect what appeared to be the landmark's imminent end. Here, county supervisor Diane Jacob stands up at a rally of thousands gathered at the nature theater in support of preserving the cross.

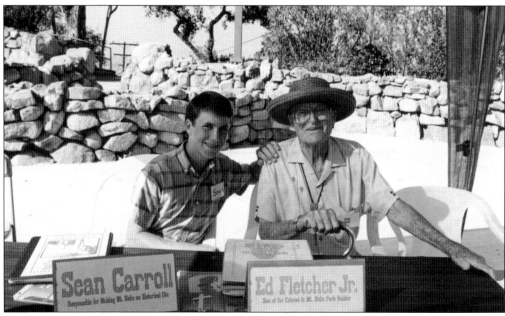

HISTORICAL HEROES, 1993. One of the most effective volunteers to respond for support was also one of the youngest. El Cajon sixth-grader Sean Carroll took it upon himself to undertake the required research, scholarship, and report preparation to nominate and list the Mt. Helix Nature Theater as a historical landmark. His sources included Ed Fletcher Jr., who oversaw the construction in 1925.

FOUNDATION FOR THE FUTURE, 1999. After difficult legal defeats, a dedicated group of local citizens offered a solution that met the needs of both the litigants and the county. The Mt. Helix Park Foundation was incorporated in 1999 to ensure that the public's park would be properly operated via a private organization entrusted with implementing the Yawkey family's intentions for this special place.

MOUNT ⊕ HELIX
PARK FOUNDATION

FOUNDATION
FOR THE
PRESERVATION
OF THE
MOUNT HELIX
NATURE THEATRE

Established April 9, 1999

Dedicated to
Ensuring the Preservation and
Promoting the Enjoyment of the
Mt. Helix Nature Theatre and Park for the
Benefit and Cultural Enrichment
of the People of San Diego County.

PARK GATE DEDICATION, 2009. The Mt. Helix Park Foundation represents a unique private-public partnership. A nonprofit's ability to raise funds specifically dedicated to the operation of the park provides greater flexibility than many public agencies. The foundation has subsequently completed planning that included improvement projects, such as this new entrance gate.

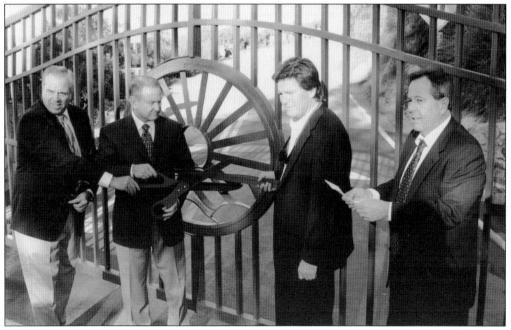

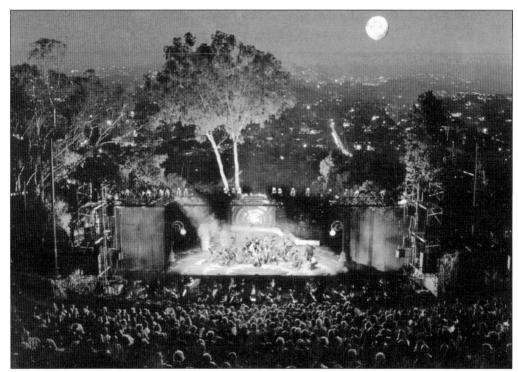

COMMUNITY VENUE EXTRAORDINAIRE, 2000s. In addition, the Mt. Helix Park Foundation has worked with local residents to work out details for accommodating special events at the logistically challenging hilltop facility. Above is one of the long-standing community theater performances that occur regularly at the open-air venue. The foundation has also expanded the park programming to include children's educational programs, nature and sustainability lectures, yoga classes, concerts, astronomy nights, and as shown below, holiday caroling events. The foundation in its first decade and a half has proven to be as valid a community asset as the facility itself.

HeART of Helix, 2014. The Mt. Helix Park Foundation raises all of its operating and maintenance funding. Its fundraising efforts include this popular annual event that mixes art and music. In addition, it works with other local businesses and organizations, such as the Grossmont-Mt. Helix Improvement Association, to provide leadership and support for the greater community.

A Millennium-Spanning Community-Based Resource, 2000. From a simple idea for a proper venue to celebrate Easter morning, the vision of so many civic leaders and generous individuals continue to make Mount Helix and its spectacular theater a true community-based cultural resource. Although the urban landscape may have changed beyond, it is still a landmark that all can enjoy.

Mt. Helix Park's Magazine

FROM THE TOP

ISSUE 4 FALL/WINTER 2014-2015

MT. HELIX PARK FOUNDATION

Dedicated to Preserving Mt. Helix Nature Theatre and Park

Volunteer Spotlight
Ron & Mary Alice Brady

heART of Mt. Helix RECAP

Fire Resistant Landscaping

NATURE | EVENTS | LOCAL HISTORY | PEOPLE | PRESERVATION

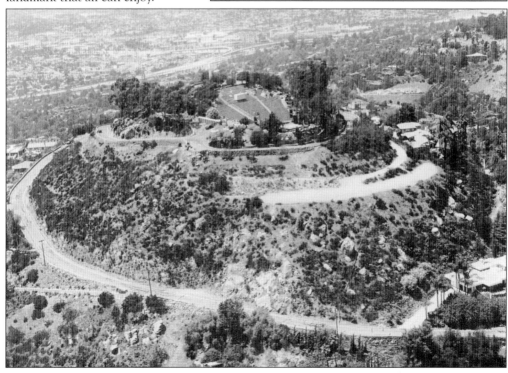

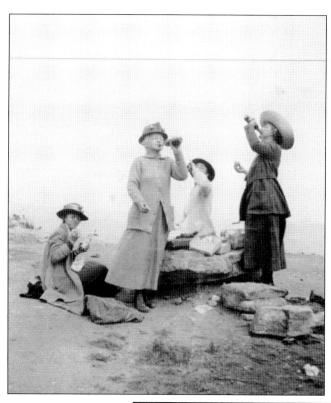

CHEERS FOR MOUNT HELIX, 1920 AND TODAY. Cheers to all those past, present, and future who have climbed its heights, enjoyed its vision-inspiring views, or worked to enhance, preserve, and protect this special place. Here is to another century or more of the same community-based spirit that drew people to this rocky peak with that unique and alluring balance of nature and culture. It is a sacred place worth preserving for future generations for the purposes so eloquently captured by Cyrus Carpenter Yawkey many years ago: "To promote knowledge and culture, to relieve the distressed in body, mind, and spirit, to cultivate a love for beauty in art and nature, to foster an interest in the love of music and elevate and refine mankind."

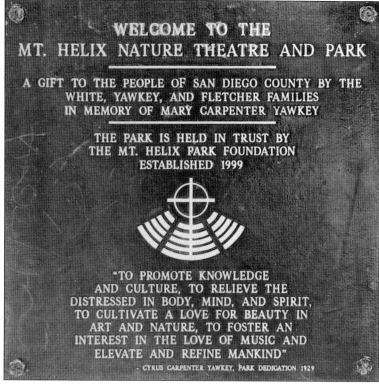

WELCOME TO THE
MT. HELIX NATURE THEATRE AND PARK

A GIFT TO THE PEOPLE OF SAN DIEGO COUNTY BY THE
WHITE, YAWKEY, AND FLETCHER FAMILIES
IN MEMORY OF MARY CARPENTER YAWKEY

THE PARK IS HELD IN TRUST BY
THE MT. HELIX PARK FOUNDATION
ESTABLISHED 1999

"TO PROMOTE KNOWLEDGE
AND CULTURE, TO RELIEVE THE
DISTRESSED IN BODY, MIND, AND SPIRIT,
TO CULTIVATE A LOVE FOR BEAUTY IN
ART AND NATURE, TO FOSTER AN
INTEREST IN THE LOVE OF MUSIC AND
ELEVATE AND REFINE MANKIND"
- CYRUS CARPENTER YAWKEY, PARK DEDICATION 1929

BIBLIOGRAPHY

Adema, Thomas Joseph. *Our Hills and Valleys: A History of the Helix-Spring Valley Region.* San Diego, CA: San Diego Historical Society, 1993.

El Cajon Valley News. Various newspaper articles 1889–1930. El Cajon, CA.

Fletcher Collection, including the San Diego Flume Company Archives. San Diego, CA: UC San Diego, Special Collections.

Guy, Herbert. *Grossmont: It Isn't Just A Shopping Center, A Comprehensive History of Grossmont, Mount Helix, and the Surrounding Valleys.* California: self-published, 1993.

Jacques, Terri Elizabeth. A History of the Monte Vista Ranch of Rancho Jamacha. M.A. thesis, History, University of San Diego, 1980.

La Mesa Historical Society Archives. La Mesa, CA.

La Mesa Scout. Various newspaper articles 1907–1985. La Mesa, CA.

La Mesa Spring Valley School District (LMSVSD) Archives. La Mesa and Spring Valley, CA.

Mt. Helix Park Foundation Archives. La Mesa, CA: Mt. Helix Park.

San Diego Union. Various newspaper articles 1869–2015. San Diego, CA: San Diego State University, Love Library.

Strathman, Theodore Andrew. "Dream Of A Big City: Water Politics and San Diego County Growth, 1910–1947." PhD diss., UC San Diego, 2005.

Van Wormer, Stephen Roger. "A History of the Jamacha Valley: Agricultural and Community Development in Southern California." Master's thesis, San Diego State College, 1986.

DISCOVER THOUSANDS OF LOCAL HISTORY BOOKS
FEATURING MILLIONS OF VINTAGE IMAGES

Arcadia Publishing, the leading local history publisher in the United States, is committed to making history accessible and meaningful through publishing books that celebrate and preserve the heritage of America's people and places.

Find more books like this at
www.arcadiapublishing.com

Search for your hometown history, your old stomping grounds, and even your favorite sports team.